Safir Anand is an lawyer, investor and as one of the most innovative lawyers in Asia. Safir has won over 100 awards for his work in the legal domain. He has contributed to many books on varying subjects including fashion, franchising and trademarks. His best-selling book *Chrysalis* published in 2021 has garnered rave reviews in the media.

Safir loves his motherland, India, deeply and enjoys writing about it greatly. This book is the fruition of this passion. He can be reached @safiranand on X (formerly known as Twitter) where he has a high following for his views on economy, India, sports, stock markets, business and policy.

INDIA UNBOXED

WE ARE LIKE THIS ONLY

75

QUIRKY ASPECTS THAT DEFINE THE NATION

SAFIR ANAND

Om Books International

First published in 2024 by

Om Books International

Corporate & Editorial Office
A-12, Sector 64, Noida 201 301
Uttar Pradesh, India
Phone: +91 120 477 4100
Email: editorial@ombooks.com
Website: www.ombooksinternational.com

Sales Office
107, Ansari Road, Darya Ganj,
New Delhi 110 002, India
Phone: +91 11 4000 9000
Email: sales@ombooks.com
Website: www.ombooks.com

Text copyright © Safir Anand 2024
Illustrations by Shekhar Sharma
Illustrations copyright © Safir Anand 2024

ISBN: 978-93-5376-981-9

Printed in India

10 9 8 7 6 5 4 3 2 1

Contents

Preface

I have grown up in India and have often been privy to conversations that paint my nation in a stereotypical manner. I have heard people blame our country for mediocre infrastructure and poor quality of life. I have sat through dinners with foreigners who still perceive my country as a land of snake charmers and an impoverished milieu who face a constant struggle for life. They criticize centuries of oppressive rule by invaders and consider India to be an impoverished nation that got left behind. Their opinions have always hit me hard. While it is a fact that India, once called the golden bird, had been repeatedly plundered by raiders, it was her resilience and willpower that made the country bounce back each time. It was also the strong will of the people who always fought for their rights, but in a peaceful manner.

There is no place like India. I travel around the world frequently, but I find peace only in *apna* Hindustan. I have a strong bond with my country. I have a great sense of pride in my homeland. I will forever remain in love with my desh.

There are many aspects of India that are worthy of love— its traditions, folklore, mythologies, quirks and beliefs. Its customs and practices define us and bind us to this land forever. India is a way of life, a habit that grows on you. She is a mother you love. A nation that you want to give back to.

India has accomplished so much to be proud of—whether it is a mission to the moon or winning the cricket World Cup or conquering the world with its brilliant minds in the fields of science, medicine, IT and management. Or simply the warmth of an unknown person who will not only guide you when you are lost on the roads, but also offer you a glass of water or even his roti despite his limited means. This caring and sharing make us a land of abundance.

This book is a tribute to seventy-five interesting things that touched me and in their own way define "Indianess".[1] To me, it is the story of the feel of India. The India we thrive in, admire and cherish. It is a sum total of the sights, sounds, feelings, quirks, we take for granted. Not realizing that these are what that make us unique and set this nation apart. *Mera Bharat mahan!*

The seventy-five quirks listed by me in this book pertain to my impression of this magnificent nation. I would love the readers of this book to share what leaves them awestruck about India. May this book inspire you, the reader, to be a true ambassador of my fascinating Motherland.

Jai Hind!

[1] The world calls it Indianness, I trademarked it as Indianess as my ode to the India that is unique, quirky and an oasis of ideas. It is simply my way of defining the India that I unbox in this book in one unique word.

Ramu Kaka

Our Indian Jeeves

If the everyday life of a middle-class Indian household were to spin on an axis, chances are it would be lovingly called Ramu Kaka! For it is around this affable personality that an average Indian family's life spins. That one pivotal human who knows every little detail pertaining to every member of the family and ensures that all their needs, big or small, are looked after.

Ramu Kaka is a trusted family member (dare you call him a butler) who 'handles it all' like a pro. He wakes up at the crack of dawn, much before his *saheb* wakes up, and can be seen busy preparing the refreshing bed tea, a scrumptious breakfast as well as his tasty tiffin for office. He is frail but feisty and so utterly trustworthy that we place everything, including our precious children and grandchildren, under his indulgent care. He can cook, raise children, clean utensils, wash clothes and much more … all this with a benign smile firmly plastered on his wrinkled face.

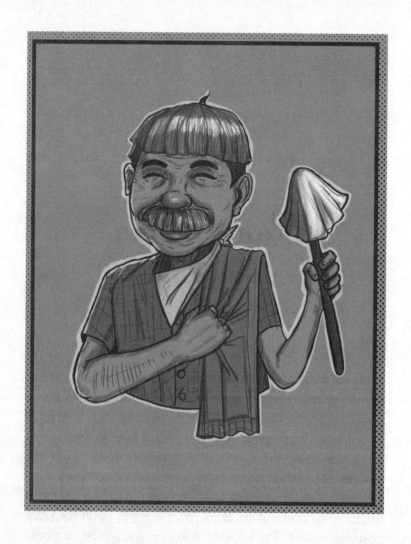

His personality instantly conjures up a stereotypical image of a slightly bent man, possibly in his sixties, dressed in a crisp kurta and dhoti with a *gamchha* on his shoulder, serving the family with true devotion and affection. A character that has deeply inspired so many Indian film-makers and scriptwriters. There are innumerable movies that have a character named

3

The Great Indian Villain

Why Should Heroes Have All the Fun?

Can a Bollywood movie be complete without the wily presence of a scheming villain? Is a hero even a hero if he does not punch the soul out of a villain? At the same time offering him a volley of dramatic dialogues that he retaliates to with equally emotion-packed lines.

The Indian villain is a verbose guy who is known to deliver loaded dialogues with the most intense look and tone, causing mayhem wherever he goes around. He is never up to any good: smuggling, looting, kidnapping and destroying anyone who crosses his path—be it the honest policeman or a law-abiding citizen. He is always surrounded by a gang of brainless, yet obedient and highly loyal henchmen who clap

Kitne aadmi the?

away, no matter what he does or says! The chorus of Yes boss resonating in his dangerous-looking den!

Unlike his counterpart in Hollywood who shoots at his victim with no remorse, like a mean machine, the Indian villain is strangely human—he likes to sing and dance though it is more like he has everyone dancing to his tune. He likes to

threaten more than he damages because though we Indians love melodrama and predictable action where good triumphs over bad, we are not so much into deep, dark movies with macabre twists and turns. Besides, don't we all want the hero to win?

Hence, hidden in this sleazy, barbaric, abusive and lusty character is a man who also wants to be loved. His quest for love and the consequent denial by a mean, selfish world turning him into the evil man he is today. This angle often makes our villains as legendary as our heroes and their role memorable and historic. Be it that of *Mother India*'s wicked moneylender Sukhilala or *Sholay*'s ruthless dacoit Gabbar Singh who featured in every mother's bedtime threat to her children, her words: *So jao nahin toh Gabbar Singh aa jayega* lulling them into fearful slumber. Who can forget the popular dialogue, *"Mogambo khush hua"* from *Mr India*?

While Indian cinema has given us many superstar villains who have sent chills down our spine with their evil acts, the thrill is that they always lose to the courageous hero in the end. And when they realize their time is up, they hog ten minutes of very emotional screen time, not just dodging multiple bullets but also showing remorse as they share the cruel circumstances in which they turned wily and wicked without much actual damage to any cause. I think it is remarkable that India has produced such powerful cameos of the villain yet shown that even they are good at heart!

Bas Do Minute

Measuring Intent

An Indian's relationship with time is complicated to say the least. We are not known to keep precise time like the Swiss, nor are we caught procrastinating like many laid-back nations, yet we all are victims of one misleading claim that does not come with a disclaimer. *Bas do minute* (just two minutes) being our catchphrase which is no measure of the actual time spent completing the task at hand. Often, we make those two minutes stretch into infinity.

Yet, we use the phrase with such alarming alacrity. The chaiwallah promises to bring you a cup of hot chai in "bas, do minute". When you ask your way up a winding alley, which looks unending, the passer-by claims your destination is "bas, two minutes" away. In our defence we Indians do not measure time, we measure intent and our sense of right direction or progress made in an uphill task. We often tell our

host that we are "bas, do minute" away though actually ETA is a good thirty minutes away. *Why?* We do this out of respect

for them and to keep their hope alive that we are heading towards them.

A person unfamiliar to the Indian way of life might assume that Indians do not value time, but in reality, when they claim that they can achieve a difficult task in two minutes, they imply that the task is easier than we think and will get completed and the other person should be at ease. This need to reassure stems from the fact that Indians are inherently warm and hospitable people. We do not turn our faces away with a look of disbelief or disgust. If too complex, we say, *"Ek, do ghante* (1-2 hours)" instead of minutes. If even more, our estimation is 1-2 *din* (days) but the spirit is not the estimation of time but the intent to finish it at the earliest possible.

Now, it is wrong to think that nothing works on time here; it is not *completely* true. Time has a significant role to play when it comes to *shubh mahurat* in matters of wedding, childbirth, *griha pravesh*, etc., and in some cases *ashubh mahurat* (inauspicious time) particularly during eclipses.

However, we like to do things in bas do minute, which is like the arrow of time—fixed to move in a particular direction and irreversible. We know we have exceeded the deadline, but we still keep running on the track of "bas do minute" with full enthusiasm. And the 1.33 billion people accurately understand what it means. And the country beautifully adjusts to complete a task.

Sindoor

Keeps Sin Door

"Ek chutki sindoor ki keemat tum kya jaano, Ramesh Babu ..."

This epic dialogue by Deepika Padukone in her debut film *Om Shanti Om* won the hearts of millions. Bright and very distinct, the sindoor is one of India's most visible cultural symbols.

If we break the word sindoor into two, we get the English word "sin" and the Hindi word *"door*(far)". So, sindoor symbolically keeps a woman safe from the sinful gaze and the evil eye.

The importance of sindoor or kumkum in a woman's life starts from her wedding day when her husband applies it on her forehead and she applies it each day thereafter. The ritual of wearing sindoor is akin to wearing the wedding band in the West. Although sindoor marks the true identity of a married Indian woman, she is also known to adopt many more symbols

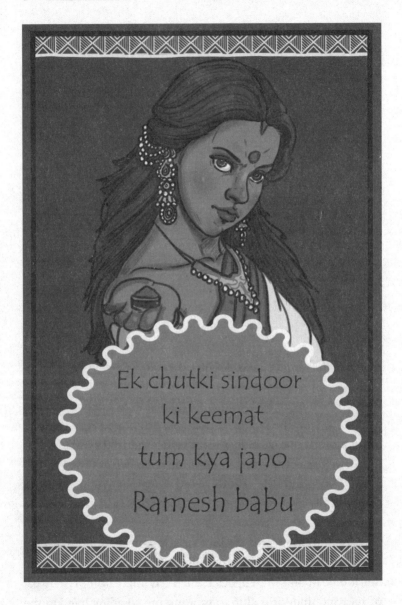

Ek chutki sindoor
ki keemat
tum kya jano
Ramesh babu

of marriage, including the wedding band, mangalsutra, *bichiya* (toe-rings), etc. The sindoor today is a matter of choice, yet

millions of married women happily opt to smear it, even in these woke times.

From ancient times, sindoor has always been a significant symbol of sacramental union between a man and a woman. It is one of the *solah shringar*s or sixteen bridal adornments that a married woman should wear on her wedding day and on important occasions later in life. The word sindoor is derived from the Sanskrit term sindoora. The etymological meaning of sindoor is red lead. Traditionally, sindoor was made with alum, turmeric, lime juice, red sandal powder and saffron, which are considered to be safe for application. As per Ayurveda, these components act as a stimulant to reproductive organs and hence boost fertility. It is also believed to regulate blood pressure and control stress.

At an emotional level, the act of applying sindoor each morning carries with it a promise of the love, trust and devotion shared by a married couple. It bestows upon the wife a sense of belonging. A privilege she loses the day she loses her life partner. Almost as if both he and the sindoor have vanished into thin air forever.

Indian Trucks

Safar ke Humrahi

"Dheere chalenge to baar baar milenge
Tez chalenge toh Haridwar milenge!"

"Hamari chalti hai …
Auron ki jalti hai!"

"Has mat pagli pyar ho jayega …"

How can anyone not laugh at these wisecracks plastered on Indian trucks? I like to call them *safar ke humrahi* because these witty and funny remarks, along with the bright and colourful artworks painted on Indian trucks, keep us highly amused all through many long and arduous journeys on treacherous Indian highways. Socio-political in tone and utterly hilarious in style, these waggish messages are possibly one of the most

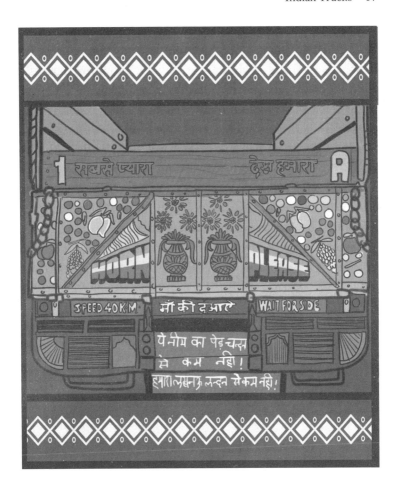

iconic symbols of Indianess. These punchlines have won a lot of accolades for their wit and humour.

They are the voice of the common man. The random thoughts of a hard-working truck driver who is constantly on the go and wants to sound like a guru, espousing gyan like *"Samay se pehle aur bhagya se jyada kabhi nahin milta."* Above all, the graffiti is the original gangster of Indian humour.

The life of a truck driver can be a lonely one because he spends 80 per cent of his time driving big vehicles on treacherous roads with only a few pit stops to bathe in community toilets, eat hot dal-roti at a dhaba, sip a cup of tea at a tea stall or catch forty winks on a cot placed by the roadside. He dresses up his truck like a bride to compensate for the absence of his wife. He shares jokes with it like he would with his children or near and dear ones. His truck's massive metal carriage is decorated with colourful artwork, beautiful motifs and enormous splashes of colours that seem to light up his otherwise mundane existence.

From "Horn Please" to "No Horn, Keep Distance", the slogans on these trucks reflect the changing times and make driving on the road a fascinating and unforgettable experience.

7

Tala and Chaabi

Our Most Trusted Security System

Indians have a unique relationship with the *tala*, the lock. A protector of all that we possess, guarding our valuables from intruders, over the years the lock itself has become a symbol of possession. For, to own a lock one needs to possess something precious enough to be locked away: be it the heart, the outspoken mouth, the temple or our abode.

Let us face it, we Indians love to lock away our valuables and precious knick-knacks that we love and cannot live without. Sights of the family stocking away their valuables in a bank locker, the owner reaching his factory on time to unlock the gate, the shop owner leaving last after downing the shutters are firmly entrenched in our collective consciousness.

A tala is a symbol of its owner's might. Often it takes the shape of law when the court comes to lock down something

with a seal that cannot be tampered with. The ubiquitous lock easily adapts its appearance to our needs—turning into a tiny

lock when it is a *sandook* that needs to be locked or a click tala for a *gullak* (piggy bank).

Locks are rendered into a piece of art in the sleepy town of Aligarh in Uttar Pradesh where the dexterous hands of seasoned artisans turn brass locks into pieces of sculpted art. In their studios we can find fish, mermaid, camel and horse-shaped locks. Each one carved to perfection with a secure locking mechanism. Many temple locks have motifs related to different divinities.

Now let's not assume that it is tangible wealth alone that we lock away. Indians also talk of locking their dreams, their hearts and their sharp tongues! So very often, parents discipline their kids by saying, *"Apne khayalon ko tala laga do."* When we want someone to keep a secret we tell them, *"Apni zubaan ko tala laga do."* The romantic at heart are often known to say, *"Dil pe tala mat lagao!"*

Tala's companion *chaabi* (key) is yet another *mastani* item. We trust her in the hands of a few who we know will keep our valuables intact. A key hanging from the *pallu* of the sari reflects authority and trust. It is the general manager of a factory who is authorized to keep the keys. And, yes, who can ever forget the iconic song from Bobby, *"Hum tum ek kamre mein band ho aur chaabi kho jaaye"*.

During ancient times, precious or personal assets were sealed in big wooden blocks, which were either placed on small islands or submerged into pools full of crocodiles that were fondly called "guardian angels". And they were deliberately kept hungry, so diving into these pools meant certain death for the intruders. For the asset owners, the only way to procure their valuables was to either drug or kill the crocodiles. Till the craftsmen invented locks, making the task of protecting our valuables less treacherous.

Today they have turned omnipresent: A grocer stocks goods worth lakhs of rupees and entrusts them on a simple lock worth a few hundred rupees or less. We rather lock our doors than depend on complex security systems that not only safeguard our valuables in our absence, but also monitor and adjust the security of our home from any part of the world. The day is not far when these smart locks will completely replace the physical ones and the tala and the chaabi will find a place in museums of antiquities.

The Indian mother-in-law might have to stop handing over the bunch of keys of the almirahs to her bahu, but the Indian psychology works on a completely different tangent when it comes to the security system. For us, a hanging lock is robust enough and much more secure even if it requires juggling to find who is holding the key!

Rangoli

Rango ki Holi

Graffiti art, colourful, flamboyant and bold, fill the streets of many countries. However, if you land in a nation where millions of homes have an interesting folkish art rendered on their doorsteps, rest assured you are in India, the land of colour, craft and culture. A country where art is not confined to a canvas. Instead, it bursts forth in many forms. Rangoli being one of them. A practice that is ours since eternity, rangolis fill our courtyards as an expression of love to our God. This practice of creating designs on the floor that are colourful, folkish and pleasing being one of the most unique quirks of India.

Decorating homes with beautiful rangoli using ground rice that is blended with different colours is an age-old Indian practice. It is believed to be one of oldest Indian art forms. In the Ramayana, there is a reference of rangoli at Sita's wedding pavilion. Many scholars claim that this art originated under the

rule of the Chola dynasty. Ever since Indians have taken great pride in keeping this magnificent art form alive.

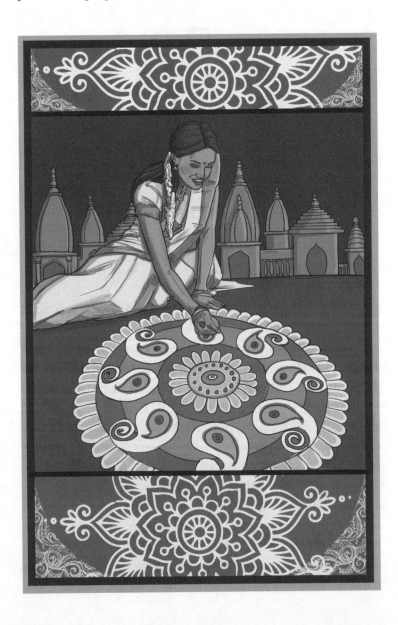

Hailed by different names in various parts of the country—*rangoli, kolam, alpona, chowkpurana, pokkalam, gahuli, aipen,* etc., a rangoli personifies the same notion of a happy, healthy and content home. Rangoli has originated from the following two words—*rang* meaning colour and *aavali* meaning a row of colours. I like to call it a *"rango ki holi"* representing the diverse elements of our culture: language, art, music, cuisine, rituals and religion.

Known to bridge gaps among people and create bonds, the art of rangoli today is often used in spaces other than home. Human resource managers of large corporations use it as a team activity, turning the art of creating rangoli to an important "employee engagement program". A competition that is well attended by both blue-collar workers and white-collar babus! While a team of art-savvy employees work together to create a perfect rangoli, even people like me who are ham-handed in art, contribute with a few swirls or colour-blocking. Besides the task of creating rangoli on Diwali is not frowned upon even by the administrator who is happy to get the office decorated at minimal expenditure. He saves on his Diwali décor budget. (After all, aren't we Indians a frugal lot!)

It is also common to hold rangoli-making competitions in schools, colleges and clubs on festivals as these bring out the artist in everyone and also help create a healthy competitive culture.

Indian airports and railway stations come alive during festivals when they are adorned with vibrant rangoli designs. The sentiment of "Atithidevo bhava" being deeply associated with the art of adorning the space where weary travellers land in quest of discovering India, the mystical land. Indeed, the nondescript rangoli that we take as routine is actually a magic potion that has the inherent power to unite people.

9

Village Graffiti

The Rustic Google Map

The practice of advertising on village walls is one of India's most interesting peculiarities. Each advert rendered like a graffiti on a freshly whitewashed wall not just promoting a commodity, but also publicizing a social message. Bright and basic in design, these unique hoardings sell anything under the rural sun: From *dant manjan* to cement; from condoms to fertilizers to even a Bollywood blockbuster!

These ads not just create awareness for a brand, they often become a vehicle for social change by promoting practices of good hygiene, family planning and education for the girl child. The central and state governments (and even NGOs) consider this medium of advertising as the most efficient way to reach the rural populace. Because the messaging is simple, catchy, unambiguous and in big, bold fonts that can easily grab public attention.

From *"Beti bachao, beti padhao"* to *"Corona ko harana hai, apna jeevan bachana hai"*, the government has been spreading social

awareness among often impoverished rural denizens through these advertisements painted on the walls of village homes. A practice that proved highly successful. Strange as it may sound, the government's propaganda to encourage villagers to trim their family to two kids (Hum do humane do) worked. The message to educate the girl child (*Beti bachao, beti padhao*) led to more and more girls going to schools. It even brought down the statistic of female foeticide.

These advertisements are also a rustic form of a Google map that helps us to navigate through the hamlet full of tiny homes and narrow lanes. Often a villager guides us to his home by asking us to take the first left from the Double Bull Cement ad, and then take a right from Dabur Lal Dant Manjan billboard and bingo, we have arrived at his doorstep!

Seeing these ads makes me feel deeply nostalgic and takes me back to the days when hoardings in cities were hand-painted too. It is incredible how a simple, hand-painted advertising on a mud-clad village wall turns into a tool of social change, also providing a means of livelihood both to the village artist and the owner of the home whose wall is painted. Not to forget how it beautifies the landscape and also helps in navigation aka Google maps. Vive le India Inc and salutations to our innovative streak.

Gobar

The Fuel That Runs Bharat

Travelling through the highways of the 1980s was almost like taking a lesson in social sciences. Unlike the high-speed expressways of today, these highways would wind through quasi towns, tiny villages and makeshift shanties, giving us a generous glimpse of India that existed beyond Delhi. As a child, I would often accompany my parents every summer on road trips to Kashmir, Mussoorie or Shimla, and on the way, we would cross many houses that had one thing in common: cows and cow dung. Dried cakes of cow dung or *gobar*, as we call it locally, were generously plastered on exterior walls of village homes. The stench of fresh dung would make me roll up my nose and I would ask my cousins to follow suit.

Today, I marvel at how India, largely a nation of illiterate farmers without access to any R&D data and residing primarily in villages, could discover this self-sufficient, sustainable and

recyclable source of energy centuries ago. They did it without any compulsion or pressure or a degree in environmental studies from Harvard!

Indians have been generating fuel for cooking without cutting trees or harming the atmosphere. And we adopted this eco-friendly fuel much before the world leaders took cognizance of the energy crisis.

For centuries, villagers have been coating the mud walls of their houses with gobar to disinfect them and also provide insulation during the scorching summer and harsh winter months. Ashes of burnt cow dung are used for cleaning kitchen utensils. It is also commonly used as manure as it significantly enhances the fertility of soil. It took very expensive researches and studies in fancy colleges to prove that cow manure, along with other forms of livestock manure, can replace non-renewable sources of energy, like coal, oil and gas, as a cheap and prime source of renewable energy. Well, all they had to do was take that trip with us down the dusty Indian roads to discover it in real time!

Bangle

A Circle of Love

Bangles, *bangdis, choodis* or *kangans*, call them by any name, they have always been an inseparable part of Indian culture. One of the most important ornaments that an Indian woman wears, especially a married woman, these circles of love feature in the sixteen forms of beautification (*solah shringaar*) listed in our ancient scriptures as a sign of *suhaag*, a symbol of wedlock.

A husband proclaims his love for his wife by gifting a sparkling set of bangles to her. When cast in gold, they turned into lifesavers for women and their families in financial distress. So many songs on celluloid centre on their beauty.

"Bindiya chamkegi, choodi khankegi
Teri neend ude toh ud jaaye"

The word "bangle" is derived from the word "bangari" meaning glass. Excavations at the Harappan sites have found

both glass and shell bangles. Thus, bangles have been central to an Indian woman's beautification ritual since ancient times.

Glass bangles are worn by women across the length and breadth of India. Most of these are crafted in Firozabad (a city close to Agra), which could be called the Murano of India because it is engaged in manufacturing many types of glass

products. The tradition of making glass bangles and bottles from recycled glass is very old in this region. These glass bangles, shaped over fire are bright, translucent, studded with stones and sequins and are often hand-painted.

Glass is made from sand and in that sense the Indian glass industry is the best example of sustainability. The artisans use blow pipes to make glass bangles which are not only beautiful, but also affordable—proving that a thing of beauty need not be expensive. The packing of delicate glass bangles is an art in itself. To see them stuck together with a small incline in a way that they would not break is a pleasant surprise.

Like all other Indian notions unboxed in this book, bangles too are linked to so many typically Indian notions. Emotions, expressions and rituals that we have grown up seeing and are firmly etched in our collective memory. Like the distressing image of a recently widowed woman heartlessly breaking her glass bangles after the demise of her husband. The act symbolizing the end of her indulgent life where she could spend hours beautifying herself for her man. The breaking of bangles also ushering her into the simple life of a widow.

Then there is that gender-insensitive word that we hear macho men often utter to weaker men asking them, *"Tune choodiyan pehni hai kya?* (Have you worn bangles?)"*. Which is a harsh way of making them feel like weak cowards. Bangles define social status. Married Rajput women, for instance, wear *jadau kundan* bangles, which are like pieces of art. These bangles are made in various styles and sizes, ranging from thin and delicate to thick and ornate. They are often decorated with colourful stones and enamel work or even Swarovski crystals.

A family's status in Punjab is reflected in the size and number of gold bangles the women of the house wear. In

that sense, these gold bangles are as much a status symbol as a Birkin bag. However, unlike a Birkin, they make for an investment too. At the time of Partition, women who were fleeing across the border to a new home and country hid dozens of bangles under their long sleeve shirts or tucked them in pockets sown in their petticoats or salwars. These bangles then helped them rehabilitate their families. A feat no Birkin could ever have achieved.

One Pill Minus the Strip

A Pill in Time Saves Nine

India is the pharmacy of the world owing to its high and efficient production of "global-standard medicine" at affordable costs. It produces the highest number of generics, and has developed a unique system of dispensation of medicine—sometimes with no brand and no name of the patient.

Meanwhile, we Indians do not like to hoard and hence hate storing medicines. We believe that not an extra pill should be bought if not needed. After all, we hate to waste.

Hence, Indians have created their own class of chemists who when shown the doctor's prescription of three meds for three days are able to decipher the requirement by way of a handy tool called scissors and give the patient exactly nine pills and save the rest of the strip for another patient. In this well-oiled system, if the patient gets cured before time, the chemist is even happy to take back the unused meds to keep his customer satisfied. This

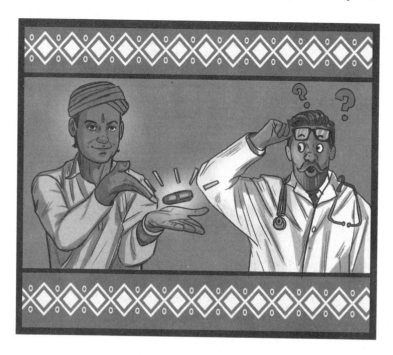

uniquely Indian practice ensures that every medicine produced is strictly consumed and none wasted. A practice I would love to protect as a strong Indian Intellectual Property.

The chemists of India have a remarkable inventory management system. The beauty of this is that the chemist is able to ensure that the meds do not get mixed up and a Disprin even with half the name gone with a "prin" remaining on the hurriedly divided strip is not misused.

We strongly believe that through this system "a pill in time saves nine". While some may question this system of cutting a strip, one should respect the fact that this unique system enables affordability of medicines to those who may not be able to afford a full strip. It also enables a patient to switch to a new medication if the medicine is changed by a doctor halfway through the treatment.

Bhaiya

The Unique Uncoded Relationship

Let me begin by mentioning that the word bhaiya is possibly the most used prefix while talking to an Indian man, known to us or totally unknown. In a country with so many religions, castes and communities, "bhaiya" is a unifying factor where none of these matter except for the purpose of a query or a transaction with due respect to the other. It is imperative to call a vendor, be that the *sabziwallah* or the *phalwallah*, bhaiya if we have to get a good, quality product at a reasonable price. This term of endearment also ensures that the *autowallah* bhaiya or *taxiwallah* bhaiya is a *rakshak* during our journey on perilous Indian roads. And the chowkidar bhaiya fetches fresh coconut water for us from the vendor down the road. A service that is definitely not listed in his KRA.

Now the beauty of it all is that most of these bhaiyas are not ours by blood. They are often complete strangers to us. The

term "bhaiya" helps in making an instant connect with a total stranger especially when we need instant help with directions, or a flat tyre or a heavy piece of luggage.

The beauty of the uncoded bhaiya relationship is that it often ends without a fight leaving the bhaiya to find another relationship among the masses. The brilliance of this ecosystem is that nobody knows the name of a bhaiya.

Also, while explaining a point when "bhaiya *samjho*" does not work, you can elevate it to *"bhai mere baat samjho"* so that bhaiya is not offended and the deal is still sealed amicably.

If we ask Indians to identify the number of men they have called bhaiya in their lifetime, we could hit infinity.

Chaat

A Common Denominator

Chaat is *chahat* and we Indians just cannot get enough of this yummy snack with its aromatic spices and tangy sauces. Chaat is a family of traditional savoury snacks, which includes at its core a combination of five essential ingredients: carb (base), chopped vegetables, chutney, chaat masala and a crispy topping. Originating in north India, the scrumptious papdi chaat, the spicy samosa chaat, or the delectable tikki chaat are now popular all over the country.

Food historians share that chaat was created to nullify the bad effects of Delhi's water on Emperor Bahadur Shah Zafar's stomach, which is why spices were added to make it stomach-friendly. And when it became too spicy, yogurt was blended in to neutralize the sting of the spice, and bingo, one of the best snacks of India was born.

Over time many other variants of the chaat evolved: raj kachori, aloo chaat. Innovation centred around the ingredients and not the practice of blending many tasty things together and serving it in a disposable bowl made from leaves or recycled paper.

There is a chaatwallah in almost every market of India, churning out one delight after another and leaving us craving for more. No surprise then that even foreign dignitaries, including, recently, the Prime Minister of Japan, Hiroshi Suzuki, could not resist trying out our truly Indian wonder. While it may appear to be something "easy" to rustle up, what with so many chaatwallahs getting it right across India, little known is that each chaat tastes different. Such is the impact of the Indian chaat that not only did it make it to the menus of many opulent hotels, it is now well-recognized even across the world. It is also one of the factors causing the world to adapt to our spices and the Indian zest to spice up life.

Champi

A True Champ of India

I would regard *champi* or the Indian traditional head massage as a true champ of India. There is a sense of utmost joy when we Indians go for a haircut because apart from the task of cutting our hair and making us look good, our barbers excel in the divine art of giving us a delightful champi, or a brief massage to our heads that truly and instantly transport us to heaven. The barber, an expert masseuse to boot, diligently applies pressure across the scalp to revitalize the blood circulation while creating an immense sense of pleasure, relaxing our minds and shoulders.

In a barber shop, one would often see people from different walks of life united by one look—of a relaxed person—with oil applied to their hair. All kinds of oil from almond to coconut to mustard are used to remove headaches, migraines and the after-effects of heat. The uniqueness of the craft lies in the

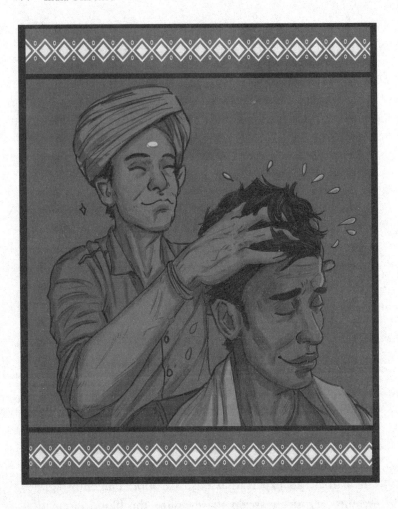

way the masseur applies different strokes of pressure from his fingertips, softly turning the demon of tiredness into bliss. Our first remedy for tiredness is this five-minute wonder that leaves us wanting for more.

The champi is a much-loved ritual whether rendered in a roadside one-seater barber shop or at a five-star salon. We also have the master craftsman, the khandaani masseur roaming

around in public places with a collection of bottles of oils to kick-start the relaxing, rejuvenating experience at any doorstep. This way of life is immortalized by Mohammed Rafi in a famous Bollywood song from *Pyasa*:

Sar jo tera chakraye ya dil duba jaye
Aaja pyare paas humare
Kahe ghabraye kahe ghabraye …

Sun-sun-sun are babu sun
Is champi mein bade-bade gun
Sun-sun-sun are babu sun
Is champi mein bade-bade gun
Lakh dukho ki ek dawa hai, kyun na aazmaye
Kahe ghabraye, kahe ghabraye

Now you don't have to go to a salon or a spa for a good champi. There are so many born-again masseurs at home. The father, the mother, even the eldest sister or the Ramu Kaka at home can double up as perfect masseurs. So a daughter or son will sit on the floor and the mother–father masseurs will sit behind him/her to apply the oil, massage the head and use the relaxing moments to discuss family matters, give updates or shower affection. Their hand movement and pressure increasing or decreasing in sync with the urgency of the topic of discussion.

16

Tu Mera Raja Beta Hai

The Magic Words of Submission

In a patriarchal society like ours, bearing a son is akin to winning a trophy. An Indian mother uses a range of adjectives as terms of endearment to address her *beta* (son) with *raja beta* topping the list.

For example, if her son is not eating or doing his homework, the mother will elevate him from being just a beta to a raja beta in order to cajole him to do the needful. *"Tu mera raja beta hai"* are the magic words that can make any beta easily fall asleep, be less anxious, eat, feel better, etc. Sometimes the cajoling is qualified by a melodramatic request, *"Ma ki baat nahi manega?"* which has the son do exactly what the mother wants. When the raja beta is in full compliance with his mother, she shares the

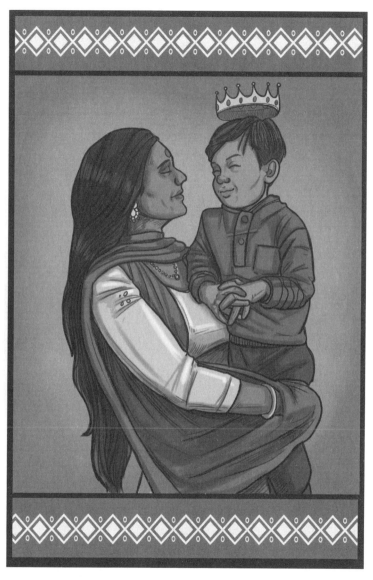

fact with her relatives and friends with much pomp. This system
of incentive and reward and love is the core of the relationship
between mother and son.

Today when Indian society is slowly moving away from patriarchy, recognizing the importance of the girl child, raja beta is also used for the daughter to inculcate the sense that she is nowhere less in strength or ability than a son. The beauty of these magic words *"mera beta"* or *"Raja beta meri baat nahi manega* (Won't you listen to me?)?" is that it carries a whole sentimental weight, heavy enough to cajole a child into studying, eating, sleeping, you name it.

Fighting Fit

The Argumentative Indian

The argumentative Indian is a real thing. Our struggle for freedom from the imperialist rule is witness to that. Under Gandhiji's leadership, Indian freedom fighters literally argued their way to Independence. They raised slogans, vociferously fought against discrimination and won their independence without massacres blooding our landscape.

Arguing, however, is not just a tool used by activists, politicians and trade unionists in India. It is something that the common man likes to indulge in as well. We are a nation of hot-headed people who argue at the drop of a hat, contesting beliefs, standing on counterpoints and expressing ourselves almost as if we are fighting a case inside a courtroom!

We are ready to argue with anyone who denies us the right to skip a queue. We raise our fist the instant someone comes even close to our "parked" car or scratches our dear,

divine jalopy. We instantly hop out of the car and start arguing
with the offender. So convincingly that we could put any good

lawyer to shame. But we do not get paid to argue. And often we do not even win the debate. But debate we must.

So intense is our love for arguments that we get into a shouting marathon anywhere: on the streets, at the airport, in a movie hall, inside a bank and sometimes even inside a wedding pandal! It is not sufficient that only two people argue in a public space. We shriek with gusto till an audience gathers around us allowing us to play to the gallery. Before we know it, the crowd is running a poll to select the winner. They even participate in the quarrel in a bid to make their person succeed and become a hero in the eyes of the gathered audience.

Indians, like the Roman, like to gather around any fight even if it is a cockfight, which by the way was a sport much enjoyed by the nawabs of Awadh. Even on celluloid, our hero is shown to fight a dozen men single-handedly. The fight is tough but he is tougher, even wiping off that occasional splat of blood from his handsome face or lips, intense in his pursuit. His punches are reminiscent of the legendary boxer Muhammad Ali who took quite a few blows before he finally hit back.

Overstep and flout our home boundaries and be prepared for the verbal opera that follows. But Indians are much more vocal than violent. We shoot from our mouth, we hurt with our words and we never ever shy away from speaking our mind simply because we are centred in our beliefs. We were invaded, looted, subjected to discrimination and exploited, yet we stood tall as a civilization, our faith in our ability remaining untouched. A gutsy fight among our fellow citizens is routine, but if an outsider tries to question our core, well, we simply allow our words to do the fighting!

18

Bhishtis And Paniwallahs

The Unsung Heroes of India

Nothing satiates the soul better than a glass of chilled water gulped down on a scorching hot day. The bond between the hot sun and cold water is "watertight". A connection that is not deterred by shifting sands of time or changing trends, especially in a country like India where temperatures soar and heat waves grip the nation, forcing dehydrated people to scurry for a drop of water. Better still a glass full of chilled H2O lovingly handed to them by a *bhishti* or water vendor. A tribe of dwindling heroes who remain part of the many quirky Indian tales that are worth unboxing and celebrating.

In *badshahi* Dilli, there used to be a tribe of water carriers called bhishtis. Those of us who grew up in the Delhi of the

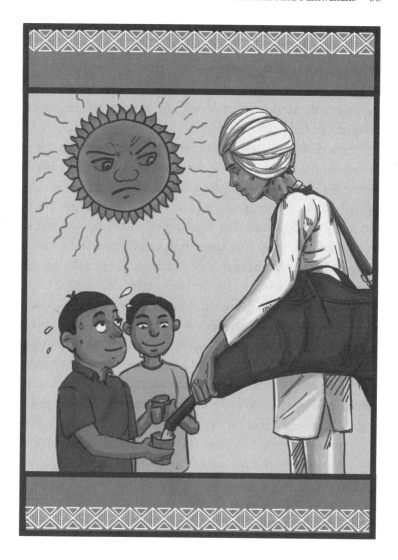

1980s distinctly recall our trips to the walled city where a bhisthi would quench our thirst with water he had filled from a dargah's well. There he would be standing, in a nondescript corner of Chandni Chowk or Jama Masjid, bent over with the

weight of the fifty-gallon water he was carrying on his back in a sack made from goat skin. Lovingly pouring out water from his hand-made, biodegradable sack, which was a piece of handcrafted marvel, he would quietly quench our thirst, moving to the next parched person. A sight that is rare, maybe even extinct today.

Historically, the bhishtis served the Mughal army. They managed to remain relevant throughout the Raj era. Much before the onset of distilled water in a bottle that could be easily bought from any grocer, the bhisthi would quietly fill the many earthen pots that were found in the homes within the walled city, as well as the water stations that were called *piyaos* in Hindi. Till the arrival of the fridge in every home and packaged water in bottles made them irrelevant.

Surviving them were the *paniwallah*s who, till very recently, were seen at many bus stops, recreational parks, busy boulevards or crowded office complex where millions of thirsty souls worked. They would stand behind their mean machines, shiny carts made of aluminium that stored a gallon of *thanda, thanda, cool, cool* water. Don't ask me what technology kept the water chilled. All I recall is sipping glasses of chilled water that were not more than five paise each. The paniwallah probably filled the water from a resource point that was miles away from his point of sales. He quenched our thirst with an icy-cold glass of water served in a glass tumbler that he bought in bulk and washed all day long from a basket filled with detergent, pricing each glass at Rs 5 or 10.

Not as ubiquitous as before, these water vendors can still be found in select places. Although the price of their glass of water has soared due to inflation, this roadside water bar remains intact as a saviour for many from the scorching heat. It has stood the test of time. Innovation and Indians are joined

at the hip hence the paniwallah aka our streetwallah bartender has gone for a brand upgrade by adding a refreshing nimbu pani or a Rooh Afza sherbat to his "menu" to give his customer a choice.

I think it is time we acknowledge the paniwallahs for their invaluable contribution to society. Often lost in identity with no brand name except a generic paniwallah and recognized by a silver-coloured cart with a water pump glistening on its shiny top, a row of glasses lined in a row, with some holding a yellow lemon, he is a sight so common that we take him for granted. But by serving thanda and *taaza* pani, he is in a way serving the nation like many unsung heroes.

Motichoor Laddu

The Soft Ball of Joy

The word *motichoor* has a melodious quality to it. *Moti* means pearl and *choor* means crumble, and, when used together it rustles up the vision of a sweet filled with crushed pearls. The laddu is the unofficial national sweetmeat that is primarily made of flour, ghee and sugar or jaggery and garnished with nuts and *vark*, and is an integral part of all celebrations in the country. The halwai first kneads gram flour with ghee and sugar and then shapes them into perfect balls that are further lined with minuscule pearls that are fried and then dipped into melt-in-the-mouth syrup. Divine and delicious. Its close cousin *boondi* laddu uses larger fried besan balls, while motichoor has tiny besan balls. This mithai can be eaten in many ways, warm or cold, solid or molten, but it always tastes great.

This favourite festive treat is popular across India and is commonly offered as a prasad. The laddu is said to have

originated in Rajasthan and Uttar Pradesh. The much-loved Lord Ganesha always keeps it tucked in his left palm. We can easily find this sphere-shaped sweet delight in almost every sweet shop in India. We welcome the bride in our family by stuffing her mouth with a laddu. We announce the arrival of a newborn by distributing boxes of laddus among our neighbours

and near and dear ones. On Diwali, we lure Goddess Lakshmi with a silver thali laden with laddus. On Holi, we lace them with bhang. India's love affair with the laddu is eternal.

In fact, the craze for this yummy sweet dish has led people to attempt setting records in making the largest laddu, softest laddu, the laddu with the maximum amount of condiments, etc.

Ironically, the globules of besan held together with thickened sugar syrup was originally used for medicinal purposes. Sushruta, the father of Indian surgery, made his patients eat laddus made of sesame seeds, jaggery and peanuts due to their immense nutritional properties.

According to historical evidence, men in the Chola Empire would carry laddus wrapped in a piece of cloth as a symbol of good luck during wars. The sweet's long shelf life was an added advantage for warriors who used to be engaged in battles for months.

In popular Indian culture, laddu has multiple connotations. For instance, a slightly obese person is lovingly called a laddu—"Tu laddu ban gaya hai". There is a popular saying in India, "Shaadi ka ladoo, jo khaye vo pachtaye aur jo na khaye vo bhi pachtaye". It explains equal chances of regretting in both the conditions, that is, marrying and not marrying.

Saunf And Mishri

Our Perfect Finale to a Bhojan

If you are a true Indian, you have surely eaten *saunf* (fennel seeds) and *mishri* (rock candy) at the end of a heavy meal. Especially when you dined at an Indian restaurant, or, indulged your taste buds to the hundred-odd dishes, each spicier than the other (and as exotic) served at a big, fat Indian wedding. Saunf and mishri, the quintessential mouth fresheners, have been the parting shot, the final offering or the free takeaways at most Indian restaurants.

One of my fondest memories of going to these restaurants with my family or friends was sneaking fistfuls of saunf and mishri in a tissue paper to smuggle it back home! Or downing spoons after spoons laden with the stuff whilst my parents settled the bill. And, of course tipping the waiter. Mind you, the "saunf-mishri" act then was basically a cue to tip the waiter who had diligently served us through the evening. This is much

before service charges were systematically added to our bill and we could not get away by giving a minuscule tip. Basically, leaving all your petty (no pun intended) change behind! Serving this combo to perfection remains a design fetish for most Indian eateries who go into deep thought of how to serve the saunf with mishri, discovering the most innovative way to present it to you in carved wooden platters, vintage paan *daans*, refurbished jalopies cast in copper and other artefacts. Some add a dash of clove to enrich the taste. It is their way of thanking their patrons for choosing them over others.

How many of us are aware of the true value of eating fennel seed? It promises innumerable health benefits. Apart from being a mouth freshener, saunf also acts as a great digestive aid. The oil found in its seeds is used in massage blends to calm the nerves and promote mental clarity. Consuming fennel seed drink during scorching summer provides a cooling effect to the body. It beats bad breath, acts as a laxative, aids in weight loss, helps control diabetes, works as an antacid, controls cholesterol levels, regulates water balance, protects us from microbes and prevents flatulence! While mishri provides an instant energy boost after an indulgent, lethargic meal. And we thought it was just a fun finale to a greasy, rich curry meal!

This further reiterates my belief that we Indians know how to derive the best out of the food we eat, both health and taste wise. Hence the fennel seed turns into candy when coated with bright coloured sugar crystals. In South India, fennel is coated with aromatic menthol leaving a fresh taste in the mouth after a spicy meal. A pinch of powdered fennel is added to the tea to bring out just the right flavour. Mishri and saunf are what add that delectable touch to sweet paan. Certain lentils and curries are generously spiced with fennel cooked in a ladle of ghee. Not to forget how it is seasoned over certain Indian desserts!

Paanwallah

The Neighbourhood Agony Aunt

Think of a detective who is not with the CIA or the Indian RAW but knows every little secret of the people living within one kilometre radius of his *dukan*. Someone who does not speak a word out of turn, yet hosts endless adda sessions at his small store with people, mostly strangers huddling together at all odd hours. Cigarettes, paans and toffees are stocked enticingly inside a row of glass containers that line his 5-foot by 5-foot stall. A teeny-weeny space that is so well stocked that it can easily pass off as a mini mart! In fact, he can teach a thing or two in space and cash management to students of management.

Yes, you guessed right, I am talking about the *paanwallah* we cross each day on our way to work or when running errands. That nondescript man who often even fails to catch our fleeting attention, However mind you, he is no ordinary mortal, he is the fulcrum of any neighbourhood, the magnet

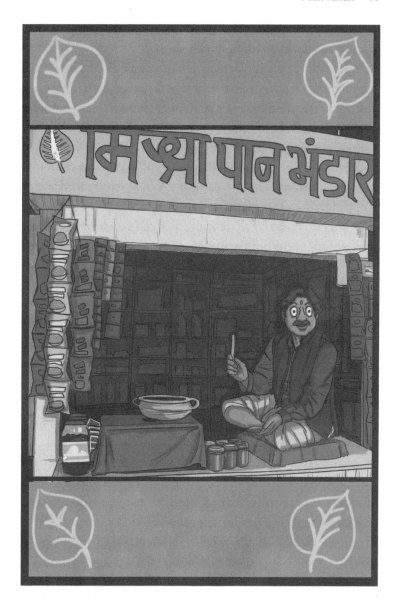

that draws many to his tiny *paan ki dukan*. Smokers, paan lovers and people with a love for gossip invariably converge at his store

to have a freewheeling chat on politics, social (even personal) issues and almost anything under the sun.

He is more perceptive than an HR manager. He knows that the monetary status of Sharmaji is shaky when he is not paying upfront and asking him to maintain an *udhaar* (loan) book for him. He can direct a guest to any home better than Google map as he adds his human touch beyond a machine. Even when he is busy lining our paan with *chuna*, mind you this chuna we welcome with a smile, he can offer a character certificate to every member of our family.

He is no ordinary vendor. He is a self-taught artist whose paan always turns out perfect, even when he has over a dozen varieties to offer. The melt-in-the-mouth *maghai* paan made from tiny betel leaves, the sharp-flavoured Banarasi variety, the calming *saada* (unsweetened) or the *meetha* (sweet) paan loaded with *gulkand* (a sweet preserve made of rose petals) that freshens our mouth in an instant. His quirky take on the paan include the fire paan that never sets any mouth on fire, chocolate paan that is soft and sweet and the chilled ice paan for our scorching summers! Isn't it incredible that while his product is ancient, his adaptive skills help him to add to the experience of chewing a humble paan?

The art of making a perfect paan does not fall in the category of an assembly-line production aka McDonald's. Yet, it always tastes the same. Indeed, there are many common points that bind the tribe together: A paanwallah has a unique style of dressing and his shop can be easily differentiated from any other vendor's shop. Many of the products that a paanwallah stocks are not branded and yet distinctive—defying the concept of trademark law. Even his posture is distinctive: legs folded, chest upfront and hands always busy rustling up a paan. Paanwallahs are mostly known by their surnames, Chaurasia, Sharmaji,

Panditji, Vermaji. There may be millions of paanwallahs in India, but each one is unique.

Even his pouch is special because it prevents the paan from spilling. Most of the material he uses is biodegradable, thus making him an eco-friendly vendor. Although undisputed in his area of operation (as one neighbourhood usually has only one paanwallah), he remains the finest example of the Darwinian theory of the survival of the fittest.

Chai Pe Charcha

A National Pastime

The Japanese host a culturally rich tea ceremony preparing and presenting their unique Matcha-flavoured green tea to their guests. The British are known for their gracious high teas where nobility and royalty meet to discuss the weather, politics and art over a well-brewed tea and scones. The Chinese their meals with a tiny cup of green tea which is generally poured from hand-painted teapots. While the Bhutanese begin their day with a salty concoction of butter melted in rice water that they call tea.

For us Indians, every moment is a perfect chai moment. We can sip cutting chai (chai that was served in tiny glass tumblers at local tea shops) at all odd times and strike a *"chai pe charcha"* (conversation over tea) at the drop of an argument. Just like humans breathe in oxygen to survive, Indians drink chai to make a moment come alive.

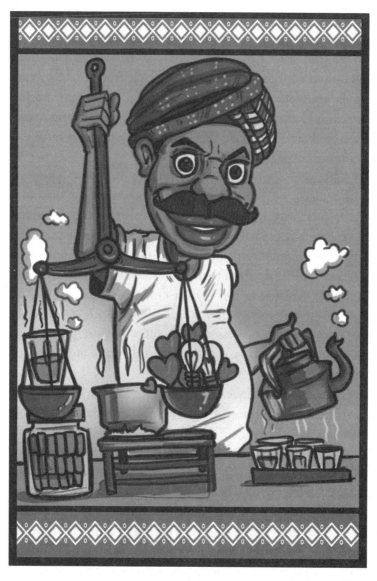

Interestingly, tea did not exist in India till the British passed the Indian Tea Cess Bill in 1903, pumping in money for the inculcation of the tea-drinking habit among Indians. They took

over the mountains of Darjeeling and the Nilgiris, planting tea and turning them into thriving tea plantations. This was their bid to break China's monopoly in tea export. They even discovered an indigenous tea plant in Assam that had striking similarities with the one grown in China. Hence, the world's three most loved varieties of tea, Darjeeling, Nilgiri and Assam tea were born. Above all, they succeeded in making India not just tea drinkers but almost tea addicts.

Chai plays a pivotal role in bringing Indians together, be it at a social gathering, an internal brainstorming session, a crucial pitch meeting with a client, or a meeting of two families to arrange a betrothal between their daughter and son. Many a time, the focus in these meetings is not the agenda to be discussed or the decision that needs to be taken but to ensure that *"chai thandi na ho jaye* (The tea must not turn cold)". And if someone refuses tea, they are told *"itni si pee lo* (Have a tiny sip)"* probably to suggest that it will add more pleasure to their life. Chai is a trustworthy companion to many laid-back chatter sessions.

An Indian's faith in tea is sacrosanct. It is a crucial ingredient to succeed in exams as it helps one to stay wide awake while studying. It is known to heal cough, fever and cold. Indians never travel without a thermos for long-distance road trips or train rides because a refreshing break is always welcome. The chaiwallah screaming, *"chai garam* (hot tea)" at railway stations is firmly entrenched in our collective memory. I am sure many of us have shared *gupshup* over chai with complete strangers inside a train or at a railway platform or in tea stalls. No matter where we go in India, a cuppa will always welcome us.

Chai has quite a few "besties" like the Parle-G biscuit that allows us to enjoy an immersive experience every time we dip the glucose biscuit into the piping-hot beverage. Other pals

include samosas and pakodas that are especially sought after on sultry monsoon evenings. *Elaichi, dalchini, saunf, adrak* and *laung* are essential ingredients of the much-loved masala chai.

There are different ways of making tea across India. For example, in the milk-loving states of Punjab and Haryana, it is made purely from milk with no water added. Though it is debatable whether they are having chai with milk or chai-flavoured milk. There is a chai for every moment. It is common to sip bed tea before having chai *nashta* (breakfast). Then there is the cup to welcome us to work, the evening tea and then the nightcap! Sometimes, we offer *chai pani* as a reward for a favour someone has done for us. Be it *kadak* chai or cutting chai, one serving of it is not enough.

The tea industry is perhaps one of the largest sources of employment as it is not just about the pluckers or toasters but the million chai stalls, dhabas, tea vendors who thrive across the country. There is the community of tea pluckers and processors, and then there are chaiwallahs found at every *nukkad* of our country. No wonder, Prime Minister Narendra Modi's *Chai Pe Charcha* is also a phenomenon, uniting Indians of all castes and creeds.

While tea might have been an accidental discovery by the Chinese, the Indians's *chahat* for chai, has proven to be an eternal love affair.

23

Arranged Marriage

A Deal Fixed over Samosas, Mithai and Chai

Marriages may be made in heaven but are arranged by parents on earth at least in most of India. While the youth across the world wait to fall in love before they say "I do", the practical Indian youth allow their parents to scout around a life partner for them. Someone who is perfectly matched, in caste, family status, upbringing, and, hopefully, mindset. Relying on their parents' experience, they let them find their perfect match.

Believe it or not, arranged marriages have stood the test of time in India. The parents carefully measure the couple's compatibility by applying various tangible parameters like religion, educational and professional qualifications, career prospects, food habits, lifestyle choices, astrology, numerology and, of course, level of affluence. To bring oneself up to speed about the requirements, all one has to do is read the matrimonial column of a Sunday newspaper that

runs into several pages. Qualities like fair complexion, good height, convent education and God-fearing, NRI status, are highly coveted.

In a nation that truly believes in harmonious coexistence, it is not for us to judge any ritual or tradition. Instead, I would like to compare the "selection process" of an arranged marriage to the stringent process of hiring by HR managers of large corporations.

Hiring someone for an important position is a carefully planned process that takes some time to complete because of the layers of screening involved. Apart from clearing tests and interviews, salary negotiations are critical before a job is offered.

Similarly, a marital alliance, which is considered to be a relationship that is believed in India to last seven lifetimes with full family commitment, also takes a long time to complete. However, an arranged marriage is the decision taken by an entire community. Marriage proposals are discussed over samosas, pakoras, mithai and chai that soften the heart. Served in style by the prospective bride all dressed up. The family's finest cutlery, crockery and linen are brought out. Whereas, a job interview is held in an office space and the deal sealed over a cup of insipid coffee or tasteless chai! The beauty of the arranged marriage in India is that it is not just about a boy marrying a girl, but the union of two families. While at times the compatibility between the family members becomes tough if there are culture mismatches or even a difference of aspirations, most marriages "work like marriage". Simply because we Indians are easy-going by nature. Besides, even when the couple are not really compatible, the family ensures that the D (divorce) word does not cross their mind. The entire community eggs them to chug along, for their sake, their children's sake. The family's belief in marriage weighing heavier on the scale when compared to the couple's pursuit of a divorce!

Pagdi

Sar Ka Taj

Indian men are big into headgear. They adorn their scalp with a large variety of turbans, hats and caps. Often making these headgears a symbol of their pride. The turban commonly called pagdi (or pagri), is a symbol of pride for the Indian male and his family's honour. It is treated with utmost reverence and respect everywhere and is often worn on special social, religious and cultural occasions.

India is known for its variety of cultures and traditions. Each community has its own distinctive identity through their standard of living, food, clothing, religion and so on. One distinct feature in every culture is the headgear that they wear. Headgears are worn by Indian men of all ages. They vary in style, colour and size depending on the wearer's region, religion or caste. It would not be wrong to say that there could be more than 500 styles of headgear worn across this diverse nation.

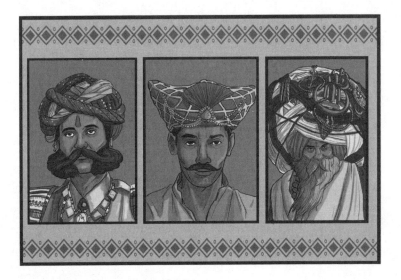

In some Indian states like Rajasthan they are simply a part of a man's daily attire, and in many ways his identity. There is a different pagri worn by a shepherd, a warrior, a trader and a king. The Marathas sure do love their pagris. If you happen to attend a Marathi wedding, you are sure to see every man's head covered in a beautiful *pheta* (a turban draped around the head with a long piece of fabric falling on the back like a tail that is called *shemala*). The colour of the pheta is linked to the region and occasion. Saffron-coloured pheta, for instance, denotes valour and its origin can be traced to Chhatrapati Shivaji's era. White symbolizes peace and you often see a dignitary being honoured in Maharashtra with a white pheta. The Mysuru pheta, the Marathi pheta, the Puneri pagdi are some of its variations. The royals of Mysuru wore the opulent formal Mysuru peta. This was made of luxurious silk and embellished with precious gemstones and zari (gold thread). Nowadays, Mysuru pheta turbans are worn as formal attire for

special events such as weddings, religious gatherings and award ceremonies in the region.

The turban worn by the Sikh community is a type of headgear based on cloth winding. Wearing turbans is common among Sikh men, and infrequently women too wear it as a symbol of their faith. Often accessorized with peacock plumes and ornaments, young Sikhs wear them to reflect their individual personality. The Sikh turban is known as the *dastar* or a *dumalla*. Dastar means the hand of God. According to the Sikhs, dastar represents their community's honour, self-respect, courage and spirituality. The turban also helps to protect a Sikh's long unshorn hair and keep it clean.

The archetypal Rajasthani pagdi or *safa* is the symbol of Marwari pride, honour and valour. Different colours of pagdis capture the mood of the season. *Motiyapagdi* of pearl pink colour is common during July, a month of seasonal transition. The arrival of monsoon in drought-ridden Rajasthan is celebrated with *lehariya* pagdi in bright green, yellow, orange, red and blue stripes.

The *paag* is a simple headdress that originated in the Mithila region of Bihar and is a symbol of pride and respect. Indians respect the pagdi so much that taking it off and placing it before the other is a gesture of respect. Such is its value and importance that it is taken as an insult if anyone knocks it over from someone else's head.

In many communities, upon the death of the head of the family, his eldest son is made to wear the turban, signifying his new position as the family head. The custom is called Rasam Pagri and takes place a few days after the death. No matter how a person in India may be positioned, he values his pagdi as an honour he must hold and pass on to the next generation.

25

The Great Indian Baarish

Music to Our Ears

There are a variety of musical instruments played in India: the lilting sitar, the vibrant mridangam, the lyrical flute, the melodious veena, the harmonizing harmonium. But there is one sound that turns every Indian ecstatic with joy. Its melody is produced without any strings or percussion. Yet, it makes us break into a song or even a dance spontaneously. And, we sing away, whatever the pitch, no matter high or low, in sync or out of tune. It is called *baarish*, the lyrical pitter-patter of raindrops falling on a parched land. We Indians love the rain except when it damages our crops or causes floods and devastation.

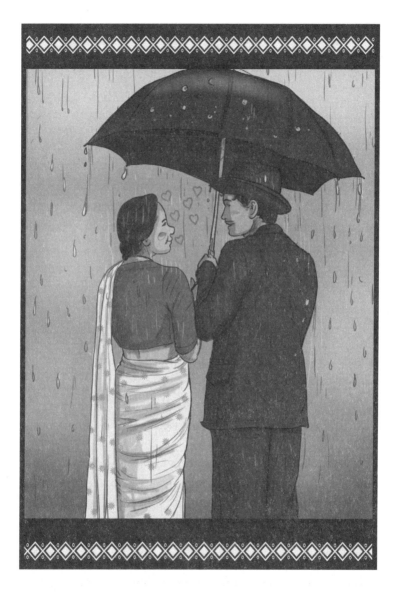

There are many Bollywood songs devoted to the rain. Like the popular Lata Mangeshkar song picturized on Sadhana in *Parakh* (1960):

O sajna barkha bahaar aayi
Ras ki puhaar layi
Akhiyon mein pyar layi

(O beloved the rain is here
Pouring down like nectar
that fills our eyes with love)

Who can forget the lanky Amitabh Bachchan striding through puddles with a petite Moushumi Chatterjee in the following classic song sung by Lata Mangeshkar from the movie *Manzil*:

Rim jhim gire sawan
Sulag sulag jaaye man
Bheege aaj is mausam mein
Lagi kaise ye agan

(The pitter patter of rain
Kindles my heart.
In this wet weather,
What is the fire that rages in me.)

Songs like these inspire us to fall in love with the natural notes of baarish. Our film-makers love a good rain so much that they time its onscreen entry to perfection. It is the exact moment when the lightning strikes that the hero hugs his heroine to fuel their romance. Our love for a good rain is so intense that even lyrics that make little sense become a hit— *Dekho baarish ho rahi hai* (see it is raining), it is raining, it is raining, it is raining!

Of course, it rains across the world, with a few exceptions, but Indians celebrate it with great gusto. Maybe the significance

of this love can be traced to farmers who still remain dependent on the arrival of *megha* for their well-being. One has to watch the peacock immersed in a divine rain dance the moment it rains. The fact that we Indians love to dance the moment it rains might be the reason the peacock is our national bird. Besides the fact of course that it is the most statuesque and beautiful bird.

The rain has inspired Indian classical music as well. It got the ustads from various gharanas to compose ragas based on them, for example, Mia Tansen's Megh Malhar. In fact, the Malhar group of ragas are best suited for monsoons and have inspired artists, dancers and writers for generations. You can find dark clouds painted on the frescoed walls of Junagadh Fort in Bikaner. Pahari paintings make umpteen references to clouds peeping through the sloping hills of Himachal Pradesh, engulfing Krishna and his consort Radha in undying romance.

We love baarish because it is one of the most foolproof ways to justify being late at work specially when we want to be late! Torrential rains not only provide respite from the heat, but also makes a hot cup of chai tastier. Baarish carries with it many friends. And I do not mean frogs. I mean those yummy crispy fritters we call pakoras made from a wide variety of vegetables. Or *pakwans* like hot samosa, hot mathris or the syrupy jalebi. All to be devoured with a cup of our favourite chai sometimes infused with cardamom, ginger, cinnamon and what have you. It is also the best time to feast on our version of corn on cob that we call masala bhutta, which magically disappears once the monsoon is over and brings us to our world with a thud.

Rain also plays the beautiful role of getting our street children to dance joyfully. Let us not undermine the sentiment here. For many street children, this is their affordable playground

with no rules. The look on a child's face as he uses the moment to splurge in his natural swimming pool is priceless.

Come the *tip tip barsa pani* (pitter-patter of rain) moment and our stomach goes on a culinary sojourn and sets our vocal cords on fire. No matter how long the queues or heavy the traffic or fragile the roof (that turns into a sieve under the pressure of powerful rain drops), the beauty of a robust baarish makes us forget them all!

Gamchha

The Cultural Fabric of India

Let me tell you a story about India's most minimalist and versatile fashion accessory. It is a strip of red and white-checked coarse cotton fabric that has a multiple use. *Gamchha* or the Indian scarf is the lifeline for men especially in rural areas of Odisha, Uttar Pradesh, Bihar and West Bengal. It is wrapped around their person in various styles, covering different parts of the body. This adaptable accessory keeps its owner happy in many ways.

When wrapped around the head, the gamchha saves the person from the scorching sun. Sometimes, it is also tightly tied around the forehead to supress a severe headache. When soaked in water and tied to the stomach, the gamchha helps prevent dehydration and, remarkably, sometimes even curbs hunger pangs. When draped on the shoulder, it turns into a fashion accessory for the common man who can ill afford high-

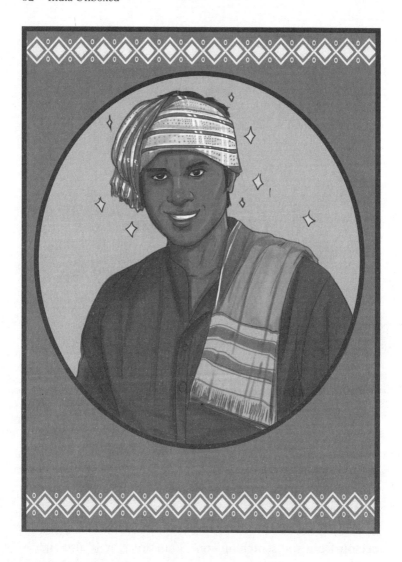

fashion scarfs. And the gamchha easily becomes a towel that wipes the sweat off its hard-working owner's face. It also serves as a seat cushion or a sheet that he covers his face with to catch forty winks.

Believe it or not, it also works like a weapon to ward off ferocious dogs. All that the owner has to do is to hold the gamchha in a tight-kneaded position to caution the aggressive animal. From a *suraksha kavach* to a towel, a gamchha reinvents itself in many forms.

So, what is a gamchha? Is it India's alternative to a fancy scarf? Or is it a bandana or a towel? It is all that and much more. The gamchha as a weave technique has its origins in Odisha. Its Assamese cousin which brings in ornamental designs in its weaves is called a *gamosa*.

The word gamchha actually comes from two very simple and commonly used Bengali words, *ga* (body) and *mochcha* (wipe). It has been worn by men of modern-day Odisha since ancient times. It finds mention in the fifteenth-century poet Sarala Dasa's Odia Mahabharata. More recently, a 1,455.3-metre long handwoven gamosa made it to the Guinness world records. It is the world's longest hand-woven piece of cloth. For me, however, it wins all existing records in how many ways men can use a garment. In a way, this fashion utility partner can be used in the most practical and frugal way and afforded by anyone, right from a landlord to the street vendor and the domestic help. The gamchha is a great socio-economic leveller.

27

Sweets of India

A Khandani Affair

The French like their macarons, the British thoroughly enjoy their teatime cakes while the Indians love their mithais. And this romance has stood the test of time, undeterred by dietary trends or fads.

Countless Indians have sweet memories of gorging on yummy laddus or melt-in-the mouth barfis or syrupy, hot gulab jamuns. While pastry chefs get trained in Le Cordon Bleu and other fancy culinary schools of the world, Indian sweetmeat makers learn the craft from their fathers and grandfathers, and keep on cooking the delicious mithais, one generation after another. Such is the power of the Indian mithai that even the confectionery giants have not been able to dent the spirit of the thousands of sweetmeat shops spread across the country.

Unlike pastries that are made of staple ingredients like flour, eggs and margarine, Indian sweets are a riot when it

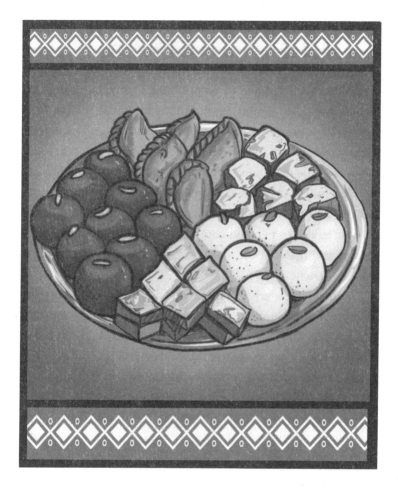

comes to ingredients. There is khoya (condensed milk) that is commonly used in many sweets like sandesh, barfi, gulab jamun. I feel with khoya (also meaning lost) in our mouth we *paya* (discover) tasteful bliss! Then there are quirky mithais like the parval (pointed gourd) barfi of Bihar, the nolen gurer (jaggery made from dates) sandesh of Bengal, the barfi made with bitter gourd and the bal mithai of Uttarakhand that is nothing but a lockjaw candy with sugary pearls covering it.

Right from Kashmir to Kerala, each state has its unique sweet dish. Mithais are an integral part of Indian cuisine. From rich and creamy desserts to jalebis, Indian desserts have something for everyone to enjoy! India's most loved desserts include the gulab jamun, barfi and laddu. But they fight hard to keep their position intact, competing with rasgulla, sandesh, jalebi, imarti and many more delicious mithais that have conquered the taste buds of millions of Indians.

The Indian sweetmeat shop is omnipresent. Almost every Indian town has a *halwai* and his son sitting in the same shop as his forefathers, perched comfortably next to the cash box or *galla*, marking every sale and tasting every sweet that emerges from the kitchen.

Indian sweets are the most affordable of snacks. A plate of hot gulab jamuns and mathri can be eaten in a mere INR 50 (less than USD 1). And this can be easily arranged at home when we have an uninvited guest because a halwai is just around the corner. Many even make the sweets at home.

"*Kuch meetha ho jaye* (Let's eat something sweet?)?" is said to celebrate any joyous occasion be that a childbirth, a promotion or a wedding. The arrival of *ma ka laddu* (laddu made by the mother) in a hostel complex sends out more cheers than Virat Kohli scoring a century.

The Indian sweetmeat industry has been able to withstand the threat from chocolates and pastries because the common man has an acquired taste for Western sweets. The industry greatly contributes to the Indian economy. The packaging industry is constantly struggling to meet the demand for boxes for the sweetmeats. The cold storage industry benefits from the kilogrammes of rasgullas and rasmalai that are transported from Kanyakumari to Kashmir. The large consumption of milk

and sugar provides a sturdy support system to the dairy and sugarcane farming community

Despite being the Diabetes Capital of the World, we simply cannot let go of the sweet tooth and the industry that thrives on it, giving rise to varieties like sugar-free sweet, keto desserts, nut-based sweets, anjeer barfi, etc. Some statistics show that despite their indulgence in sweets, the average Indian lives a long life; perhaps the sweet makes them happier. The sight of an elderly person with health issues sneaking a sweet bite saying *"bas thoda* (just a little bit)" is an endearingly common sight.

Our sweets come in all shapes and sizes. But then a mithai in any shape tastes just as sweet, and binds us in the spirit of sharing and gifting.

Gol Gappe

One Is Never Enough

Gol gappe are never truly *gol* (round) nor do they allow us to indulge in any *gappe* (gossip) while eating them. (Though *gappa* refers to the eating process.) Instead, they arrive on our plate in all shapes—from oval to round with a hint of square too sometimes—filled with a mixture of boiled potatoes, onions and chickpeas and tamarind water. The taste riot that explodes in our mouth is such a flavourful experience that it creates a lasting memory. It easily qualifies as India's beloved street food. Eating a gol gappa is a multi-sensory experience.

Prominent food historian Pushpesh Pant is of the view that gol gappa originated around Uttar Pradesh and Bihar about 100–125 years ago. There are at least ten commonly used names for describing the same dish in different regions. If we are relishing it in Maharashtra and Gujarat, it is the ubiquitous pani puri. In Delhi and other northern regions, it is called gol

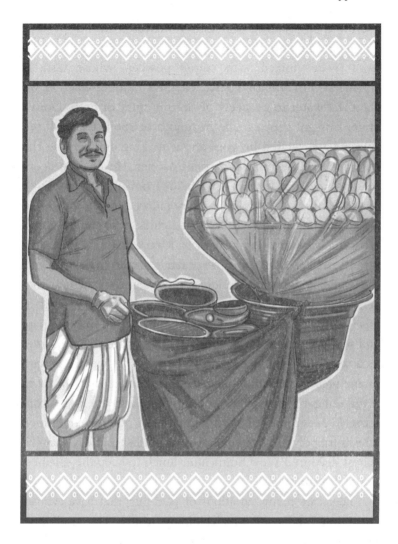

gappe and on the famous streets of Kolkata, it transforms into a phuchka. It is one of the Indian snacks that tourists have high on their to-do list. Even if they nurse a Delhi belly later.

The entire process of serving this snack is a class act. The gol gappewallah is usually dressed in a crisp white kurta

and dhoti or pyjamas, his hands are covered with disposable gloves and he stirs the earthen pots filled with the cold jal jeera (water mixed with cumin powder) whose taste is enhanced with tamarind paste. He then enquires whether we want the water to be sweet or sharply spicy or both. Do we prefer our gol gappa made from atta or sooji? Once all the answers are elicited he goes about making and serving the gol gappe in the most practised manner. He fills the deep-fried hollow, crisp flatbread ball made from either semolina or wheat flour with the spicy mixture tailored to suit individual taste bud, finally adding the boiled chick peas and potatoes. He usually serves a group of 4–5 customers, standing in a semi-circle around him, from left to right and never gets the sequence wrong. He pierces the wafer-thin shells with a gentle prod of his thumb, carves a hole in the centre of it, fills it with the right amount of mixture, dips it into the pani and serves it at breakneck speed. One after another he serves us a water-filled tasty cannon of delight that we gorge with divine pleasure. Traditionally, there are not more than six to seven gol gappe per plate. The serving plates are made from recycled paper or a leaf, which makes this popular street food an eco-friendly, guilt-free pleasure. A perfect mid-day snack, it is best devoured a few hours after lunch to keep the spiciness in the day running.

There are many variations of pani puri that have evolved over time, reflecting our changing tastes. The traditional tamarind and mint water is replaced by the green chilli jal jeera water. Those who cannot digest the tangy, spicy water are served sweet-flavoured water. At great Indian weddings, we also get to devour vodka-filled gol gappe. Pani puri tequila shot is a popular variant as well. Gol gappa has a great scope of experimentation and innovation.

As ordering food has become the norm, pre-packaged gol gappe and ready-to-use flavoured water are available off the shelf in many Indian grocery stores across the world. There is also a gol gappa kit which comes with a plastic syringe to fill the gol gappa with the water mixture.

Going out to eat pani puris is quite an Indian tradition, and for some it is a daily affair. While the devoted fans of this snack may rasp loudly about the spicy water, they forbid the gol gappewallah to add the sweet tamarind chutney to smoothen the sharpness. *Why?* Because in their hearts they like it hot. It fulfils everyone's craving and satisfies the soul. And it is remarkable that our craving has ensured that millions of chaat papdi kiosks thrive across the country.

Subziwallah

Our Morning Alarm

In most parts of the world, people wake up to the tranquil sound of chirping birds but most urban Indians wake up to the shrill sound of a *sabziwallah* screaming at the top of his voice: "*Aloo le lo*, *gobhi le lo* (buy fresh potatoes, buy fresh cabbage)!" The vegetable vendor's cart is crafted from rustic wood, laden with vegetables that he has sourced from the wholesale market early morning. By constantly sprinkling each vegetable with water, he ensures that the fruits and vegetables look fresh and inviting to his potential customers.

Mind you, when it comes to merchandise and variety of choice, his 8 foot by 6 foot cart can give any vegetable section of a grocery store a run for its money. The sabziwallah deserves a gold medal in space management because his small cart displays 20–30 varieties of produce. What he cannot display, he tucks in his storing space and fetches it the moment we ask for it.

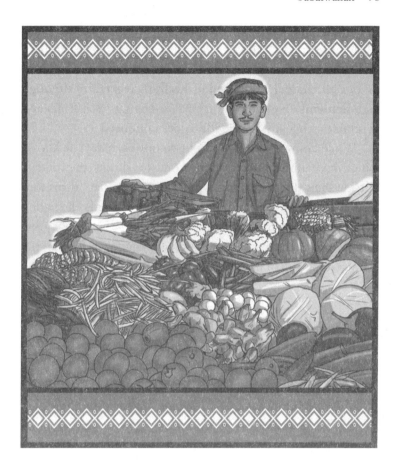

He knows what we want: drum sticks for our sambar, bhindi for our tiffin, cabbage for the paratha and crisp cucumber for our salad. For the new-age customer he also keeps what he calls *"angrezi sabzi* (English vegetables)"—broccoli, mushrooms, pak choi, iceberg lettuce, etc. He can read our mind with great accuracy and knows which vegetable to bait us with. It is all thanks to him that our families can eat fresh produce, sourced from the market and brought to our doorstep.

He is well aware of the price-conscious customer who always loves a good bargain. *"Bhaiya theek theek laga lo* (Brother, make the price reasonable)" is his cue to give us more discount on our purchase. He is proud of his fresh vegetables although we often end up taking the credit for buying fresh fruits and vegetables while his contribution goes unnoticed.

While doing the rounds of our colony each day, he knows where his faithful buyers reside. And he shouts the loudest outside their doorstep. And, often his tiny "outlet" turns into a spot for friendly neighbourhood gossip—maids discussing their memsahebs, madams complaining about their ayahs gone truant. And all this while, our basket of veggies get filled to the brim and the cup of happiness brimmeth over.

The Indian Kachha

One Style Fits All

In the pre-liberalization era, Indians wore what was manufactured in India. No matter how unfashionable, and I am not referring to khadi or the subsequent polyester movement that unified us all. I am talking about the uniform boxer briefs Indian men wore during the 19560s—1970s. These were often spotted drying on almost everyone's clothesline. The shorts were made from the same quality of striped cotton cloth and held together with a *nada* (drawstring). One style fitting all. Indian men crammed their fitted trousers with a pair of big boxer shorts that often peeped out. Not in the stylish way the young men of today allow their branded underwear to show over their jeans.

The striped underwear controlled by the nada became the butt of many jokes. The comedian's pants falling to reveal his striped *kachchha* or underwear was a recurring plot in many

movies of the era. *"Usko toh nada tak nahi bandhna aata* (He can't even tie the drawstring of his boxers)" was often uttered as a way to question fragile masculinity.

I think the vision of identical boxers drying outside every home, rich or poor, continues to be a great leveller. Though I wonder if football fans got confused, given the stark resemblance of the stripes on Indian boxer shorts to Argentina's football team's uniform!

The pair of boxers often had a hidden coin pocket and was made of breathable cotton fabric adding to the comfort. I always wondered why a hidden pocket was needed in an already hidden undergarment. Maybe because many men wore them as shorts on their day off at home and then the pocket came handy. Although I wonder why the striped boxer never became a global fashion trend. After all, the sari did. So did the gamchha. But this piece of clothing remains synonymous with the Indian man and his idiosyncratic persona.

31

The Big Fat Desi Wedding

Nothing Short of a Tamasha

Most Indian weddings are nothing short of a soap opera or a Broadway musical. They remain unparalleled in their dramatic opulence and we Indians love it. Not just us, our foreign guests too crave to witness a big fat Indian wedding and at the sound of the first dholak turn desi, dancing vigorously to bhangra tunes.

In a culture as diverse as ours, wedding rituals change rapidly. What remains universal though is the practice of arranged marriage which is a unifying factor irrespective of the caste, religion or social strata. Marriages could be made in heaven but in India they are plotted and planned by friends and relatives on earth. The moment a couple agrees to marry each

other and their kundalis (horoscopes) match, their relatives get ready to stage the "match of the century". A Test match mind you, not a 20–20 blink-and-you-miss-it match.

According to *Forbes India*, the big, fat Indian wedding industry is currently estimated at Rs 3.78 lakh crore, and expected to grow by 20 to 25 per cent annually. Wedding planners, decorators, caterers, florists, entertainers—all get together to craft a magical wedding where two hearts seal their fate forever. Except they are sometimes in the company of the 2000-plus guests invited to this wedding mela.

For the bride and groom the task of getting married feels like an uphill trek that involves many steps. First the family confirms the match over many boxes of laddus. Then there is an elaborate ceremony planned where rings are exchanged, not as a gesture of proposal but as a show of celebration for all to see.

To ensure what was sealed in heaven remains so on earth, a series of rituals are lined up. A typical Hindu wedding ceremony involves the couple taking seven rounds around a fire, their hands held together as his sash and her *odhna* are knotted together. It is as ritualistic for the Muslim couple who say *"Qubool* (I do)" to each other seated across a chaddar of heavily scented jasmine flowers. The Parsis too hold the fire sacred and the Varadhapat ceremony is the heart of the Parsi wedding. The couple exchanges vows in front of the holy fire, promising to support and cherish each other throughout their lives. For the Sikhs, the gurudwara is the place to get married as they take the vows before the Granth Sahib, their holy book. All this because the families know that the made-in-heaven theory is not foolproof, so the gods must be pleased.

The Indian wedding meanwhile is universally a crowded affair with the extended families of the couple attending in

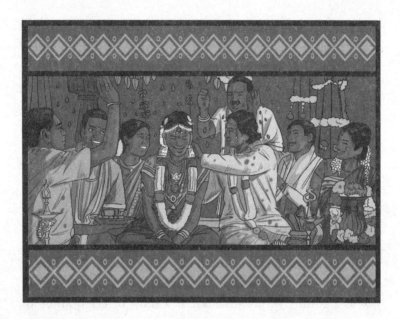

full gusto with aunts, uncles, cousins, grandparents spending a good amount of time catching up with each other. Most of them meeting each other after a gap of many years. Hence, *"Kitna bada ho gaya aapka beta* (How grown up is your son?)?" and *"Aap kahan rehte ho aajkal* (Where do you stay now?)?" ring through the wedding venue.

Generally a North Indian Hindu wedding ceremony is kicked off with a mehndi ceremony where both bride and groom get their hands inked with mehndi. The groom inscribes his beloved's name boldly on his palm while the bride hides it in an intricate design. Back in the day, when the couple did not know each other well before getting married, trying to find the name helped break the ice between them. That was before they had a dozen kids! These days, it has become a fun tradition to look for the partner's name. The mehndi ceremony is a vibrant and colourful event with lots of food, music and entertainment.

Tradition says the deeper the colour of the bride's mehndi, the happier the couple's marriage will be. See, we Indians just need a reason to rejoice.

The sangeet is when the party starts. Initially, it was strictly for the women of both the families to meet, greet, dance and sing together. But now, we have the men joining the party. The sangeet is not considered a religious pre-wedding ceremony. Instead it is an avenue to partake in the happiness that engulfs the couple. The sangeet night calls for pomp and pageantry with both families stepping on stage to present a perfect dance that they have learnt from a skilled choreographer. Songs are sung, delicious food is served and musicians and performers light up the night before the Big Day. Mind you, it is at the sangeet night that many new dance moves are brought alive. And, aunts and uncles are seen awkwardly trying the *nagin* (snake) dance. Many just stand in one place swinging their arms and hips in solidarity. This bonding activity often brings into limelight those who were shying away. Requests like "if you don't know how to dance, try a little bit!" often works. Why? Because we believe we know a little bit of everything and if we actually don't know how to dance we will soon hit the right groove.

The reception is followed by the farewell ceremony or *bidaai* organized by the family of the bride to officially bid farewell to their daughter as she leaves for her marital home. The emotions are usually high on this day, especially for the bride and her parents. While the bride bids adieu to her *maika* (the maternal home), the *baraatwallah* band lives up to his promise by playing *"Babul ki duaein lete ja, ja tujhko sukhi sansar mile* (Take blessings from your father as you step into your husband's home)". Never mind if this song has played a zillion times at many weddings, we can still make it sound unique. If the family fails to watch the wedding video together within

the first few months of the wedding, they certainly make sure to watch it at the bride's baby shower. We watch the video simply to examine how our relatives behaved and how well they got along with each other. And even years after it is all over, incidents / flare-ups / squabbles are discussed and analysed with great gusto. As they say, one can never attend an Indian wedding, one can only experience it.

The Dabbawallahs

Delivering with Perfection

Prince Charles made it a point to endorse their existence with a photo-op. Management schools of the world cite their business model as the most unique delivery operations, born much before Zomato and Blinkit were even conceptualized. A 2010 study by the Harvard Business School graded it Six Sigma, which means the famous breed of *dabbawallahs* make fewer than 3.4 mistakes per million transactions. Mumbai's pride but an enigma to the rest of the world, the dabbawallahs are a task force most omnipresent in Mumbai. Found in abundance on local train, at business hubs and outside train stations, they are seen going about delivering home-cooked food to millions of Mumbaikers in their office. Just like they have been doing for the last 133 years.

Embarking on a veritable relay race, a dabbawallah, clad in his characteristic Gandhi topi, crisp white dhoti or pyjama and

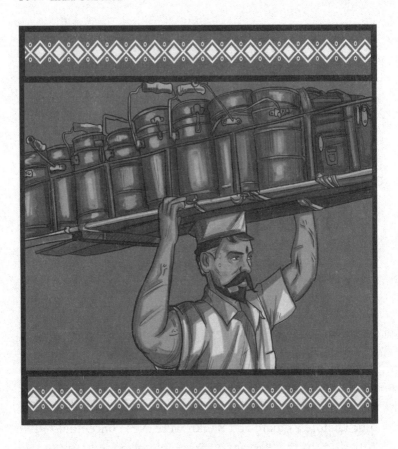

a kurta to match, picks up hot food from his client's doorstep, delivering it to him in his office, which sometimes is nearly thirty kilometres and twenty train stations away from his home. His dabba usually changes three to four hands and is kept with a sea of similar-looking aluminum tiffin boxes. Yet it is incredible how it magically reaches the exact address, on time each day, day after day. A complex identification system ensures that the package reaches the right desk of the rightful recipient. The entire city of Mumbai gets defined by multi-coloured dots and dashes. And this system beats even the most

complex delivery SOP of a tech-led delivery start-up. This world of lunchbox carriers is led by people who are ingenuous, resilient and grounded.

In the late nineteenth century, an increasing number of migrants were moving to Bombay (now Mumbai) from different parts of the country. All these people left early in the morning for offices, and often had to go hungry for lunch because restaurants and canteens were not prevalent. They belonged to different communities, and therefore had different types of tastes, which could only be satisfied by their own home-cooked meals. Sensing the opportunity, Mahadeo Havaji Bachche started a lunch-delivery service in Bombay with about a hundred men in 1890. He developed a unique colour-coded system that cut across language barriers and trained a task force that was often not literate.

So, how does it actually work? After picking up the lunchbox around nine in the morning, the dabbawallah places it inside an aluminum container. After collecting 30–40 lunchboxes from a neighbourhood, he meets other dabbawallahs at the reporting station for the sorting of the dabbas based on their delivery location. Once sorted, the dabbas are packed into crates and assigned to individual dabbawallahs. The dabbawallah then transports his crate, either by bicycle or by train, depending on the delivery location. Each crate holds at least thirty dabbas. Once the destination is reached, the dabbas are again split for final delivery to the assigned local dabbawallahs who deliver these to the final recipients usually around noon to 1 p.m.

Once deliveries are made, these enterprising professionals eat their own home-cooked lunch. After lunch, they collect the empty tiffin boxes and return them home, following pretty much the same process in reverse. It is interesting how a mammoth ocean of humanity that resides in a crammed city prefers to

eat the *sada bhojan* (simple meal) cooked at home, rather than eat at the many tiffin restaurants that dot the business district. Why? Because we Indians love our home-cooked food and I cannot fathom a hundred delis thriving here, like they do in New York, a bustling metropolis Mumbai is often compared to. Though, even if the tiffin from home takes the warmth of the family to the sober office, nothing stops its recipient to end his healthy meal with an ice cream, a gulab jamun or a kulfi from the office canteen. Or even a quick vada pao from the chaiwallah kiosk nearby.

The dabbawallahs have not had it easy. They have had to overcome challenges such as floods, typhoons, railway strikes and even a pandemic, and have had to upgrade their skills in recent years, learning English and embracing technology. In October 2020, with the launch of digitaldabbawala.com, an official website representing all the delivery organizations, the deliverymen expanded their services from lunchboxes to last-mile delivery of digital services such as electronic registration of property rental agreements and marriage certificates. Customers can now directly place lunch orders via the website, choosing between monthly or annual subscriptions paid online. The dabbawallahs are also partnering with many local restaurants to deliver food to customers, possibly beating delivery start-ups at their game.

33

Accidental Fathers in Indian Cinema

A Necessary Plot Twist

India's reluctance to talk about sex is a given. A nation of 1.4286 billion, a country that gave the *Kamasutra* to the world, we Indians have, for centuries, avoided the topic like the plague. Even today, we allow thick clouds of ambiguity to gather around sex talk. Although there was never a legal prohibition on kissing and intimate scenes in Indian cinema, kissing rarely made an appearance on the big screen for a long while. Indian masala movies instead used creative and suggestive ways to depict intimate moments. Like two flowers touching, or, the camera simply moving away as the couple moved closer, or two birds sitting close to each other on a branch. Or even the proverbial bees symbolically and metaphorically representing

a romantic and intimate moment between the lead romantic
pair who only held hands before marriage as, premarital sex

between them was a strict no-no. Except if it did happen, it led to an unwanted child, and an accidental father, reluctant to rise to his responsibilities.

The formula was foolproof and identical: The hero and heroine were forced to take refuge from torrential rain inside a hut or a far-flung lodge. Alone and close, they invariably indulge in a night of passionate love-making, this act between a fertile hero and an equally fertile heroine always led to a sureshot unwanted pregnancy. The melodramatic declaration, *"Main tumhare bachche ki ma banne wali hu* (I am pregnant with your child)"*, triggered such heightened emotions in the audience that the box office always jingled its way to the bank. It is another matter then that the unwanted child becomes the most wanted hero or star in the plot. You see, we Indians love to show our challenges as our means for success.

I often wonder if having too many children, including some that happened accidentally, had anything to do with the overzealous family planning campaign that our government launched in the 1970s and has not lost sight of it ever since. While a significant part of the population was learning about circles and triangles in schools, another part learnt that the red triangle meant "Nirodh", one of India's biggest brand success stories. We shied even at its mention.

Coming back to the famed dialogue that created such a *kahani mein twist*: An innocent baby in the making, a scared mother caught in a dilemma and a father who was not ready for a child. Cut to twenty years later and by some strange coincidence, the same child, now a grown man, gets wooed by the same father who shunned him in the first place but now wants him as his *waaris* (legal heir)!

Meanwhile, the audience is left with many questions: How did he find out he was the father? How could he accept the same

woman he had shunned years ago? How could she pardon him for the many years she spent fending for herself and her son? Predictably, the director always skims over the intimate details of the night of passion that triggered the dramatic plot in the first place, leaving the details to our fertile imagination!

Dhobi

Dependable as Ever

He plays a cameo in all our lives, yet his character is firmly entrenched in our collective consciousness. The sight of a dhobi arriving at our doorsteps, his cycle laden with bundles of clothes stacked together neatly. Each bundle of used linen and garments belonging to a family in our neighbourhood, who want every garment in the pile washed, starched, ironed and duly returned to them in wearable condition.

Every Sunday, he arrives at our doorstep to collect our dirty linen which he washes in an open-air ghat in full public view. Perched on a shining black stone, he washes each item with a yellow soap that would beat any detergent hollow. He then starches the crisp cotton bedsheets and saris and mulmul dupattas. Once the clothes dry they are taken to a makeshift table where he irons each garment perfectly. Made from cast iron and fuelled by coal, his rustic version of the steam press

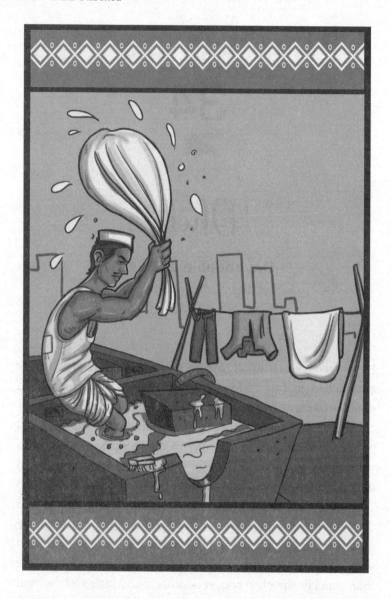

gives each garment a crispness better than any steam press and carries a unique smell of his surroundings. And he returns our clothes fresh, crisp, clean and ready to be worn.

At an average he collects garments and home linen from over a dozen homes. Most trousers, pyjamas, white bedsheets and shirts tend to look the same. How does he never mix up our clothes with that of the neighbours? How do the fabrics never tear despite the rhythmic beating they get at the ghat? How does he ensure that the vegetable dye from one garment does not run into another? In other words, what are his trade secrets?

For one, he has devised the most reliable trademark that can never be replicated. Call it the "dhobi mark" which he makes with a washable chalk. One line for house number 1, two for house number 2, etc. Only he knows how to demarcate them at the time of collection and bundle them back in the correct order at the time of delivery.

A simple soul, he spends most of his life at the ghat—a patch of the water body he owns notionally. Often, he can be found sitting with his friends singing folk songs that take him back to his village. The uniqueness of the dhobi is that even without a formal education he has his own "Morse code" evident in his dhobi marks. We grateful customers ought to give him full marks for his innovative marking and his efficient collection and delivery systems.

Another wonder is how the dhobi always finds a clean place to dry the clothes at a dirty, cluttered ghat. Another beauty of this community is that it has existed for over hundred years and is thriving despite the onset of washing machines and modern irons. Yet we prefer him and not the dry cleaner who returns our clothes insides vacuum-packed plastic bags, branded hangers and cloth bags. While our dhobi bhaiya delivers our clothes neatly piled and wrapped in our old bedsheet. In a sense, he is a part of our weekend lives and our Sundays are spent counting the garments that we hand over to him for cleaning and ironing. This ritual being yet another unifying Indian IP that is ours 100 per cent.

35

The Mysterious Indian Nod

Puppetry in Real Life

There is one Indian idiosyncrasy that completely confuses the world, leaving our visitors from overseas clueless about what we mean when we nod our head. Does it imply a yes, a no or a maybe? They stand confused, observing an Indian as he moves his head left to right or up and down like a *kathputli* (puppet) or a Kathakali dancer, his hand moving in sync with his head. It is not exactly a nod meant to indicate a "yes" or a shake to convey a "no" or a side tilt to suggest maybe. It is a smooth movement that involves tilting the head from up to down, side to side vertically, either gently or fiercely. It is not a jerky or firm motion, but even and continuous. Does it mean a clear yes? Is that a no? A maybe? A sign of

uncertainty? Annoyance perhaps? It is difficult to say without knowing the context.

Maybe our nods mimic the puppets we saw as children. Or the fact that we were puppets in the hands of our parents whose attention we got only if we nodded our heads frenetically! Or, maybe we Indians are great believers in using our body language to convey our thoughts and emotions.

Indeed, there are many reasons why an Indian nods his head. He nods in disbelief, in disdain, silently asking what is wrong with the other person. When he bends his neck, suddenly raising it firmly till the chin in an upward motion, he is questioning you. When he also rubs his hands dramatically, he is telling you he knows nothing. If he is sure of his decision, you can see his wrist and head literally reverberate in sync. When he wants to end an argument, he simply nods and closes his eyes, telling you it is over.

The beauty is that all these nods are easily deciphered across the country despite the diversity of dialects and languages. It is like a universal sign language that pervades all strata of Indians, literate or illiterate.

A simple movement of the head gets the most complex message across.

Saree

Weaving Magic through the Centuries

The Japanese have forgotten their kimono, the Scots their kilt, the Greeks no longer wear their robe but one traditional garment that has stood the test of time is the saree. At more than 5,000 years of existence, the Indian saree is considered to be among the oldest form of garment in the world still in existence. Worn daily by many Indian women, the saree is a beautiful expression of our country's diverse cultures. A six-yard drape (or nine yards in the case of a Maharashtrian Nauvari) that binds the women of India.

I would like to capture the myriad emotions attached to the saree, a piece of garment that can be draped in many different ways and woven, embroidered or printed in so many diverse styles. It is endearing how a girl in South India is made to wear a half-saree the moment she reaches puberty. Exactly half in length, this three-metre-long fabric, handwoven in

cotton or silk, is draped over a blouse and lehenga. The draping is uncomplicated and it prepares her for the thick Kanjeevaram she will later wear as a woman.

Then there are the elegant, beautiful Coorgi women known to wear their saree in a unique way. In the Kodagu style of draping, the pleats of the saree are tucked at the back of the waist. Similarly, the *pallu* of the saree is draped from rear to front tucked neatly over the shoulder. Although some stylish women also secure it with a brooch.

Then there are the feisty women of Kerala who wear the *mundu neriathum* which is simply two sets of running fabrics draped together in a manner that offers freedom of movement. The first one being the mundu that is otherwise worn by men, and worn exactly like a lungi by even the women. The second fabric, a white, hand-woven cotton fabrics with kasavu (zari) border is draped like a sarong. To the east, the gorgeous women of Bengal with their large doe eyes and thick, black hair have their own way of tying their handwoven Tangail, Jamdani and Tant saris. Pleats free, these saris mock a Roman drape and often have a dainty silver key chain knotted to it. Not far away from these erudite, intelligent women born in Gurudev Tagore's state, the women of Assam make an art out of wearing their *mekhela chador*, woven in *muga* silk (or gold silk). A three piece garment, it is draped to mimic a skirt turned into a saree with the pleats draped in an origami style.

Women from princely and noble India, especially the Maratha women, played a big role in popularising the saree. Madhya Pradesh remains the birthplace of the most enduring creations—the Maheshwari and the Chanderi saree. The Maheshwari saree was conceived and designed by Queen Ahilya Bai. Part silk and part cotton, these handwoven sarees give a sheen of silk and the comfort of cotton. Fable also has it that the Kota sarees we wear today were originally used as a gossamer net to save the rulers of Kota from the onslaught of treacherous mosquitoes. The chiffon sarees worn with such

elan today were made popular by royals like Maharani Gayatri Devi of Jaipur, Maharani Sita Devi of Kapurthala, Princess Nilofer of Hyderabad and many other queens and princesses.

Indian women have flaunted the saree everywhere with pride. The soft-spoken Sarojini Naidu wore it to Cambridge; the dynamic former Prime Minister Indira Gandhi coupled her crisp cotton sarees with her ballerina shoes; Kasturba Gandhi wove her own khadi sarees as an ardent patron of Swarajya. The saree can be made provocative, sensual or chic, depending on who is draping it and how. It is possibly the most versatile of all garments in the world.

It was the cinema of the 1960s and 1970s that turned the saree into such a fashion statement. Suddenly, the common Indian woman wanted to add a sequinned chiffon worn by Madhubala, the woven Banarsi immortalized by Vyjayanthimala Bali or the printed, floral sarees worn by Rakhee to their wardrobe. It was much later that Zeenat Aman brought in the oomph factor to the drape. Whilst a glamorous Dimple Kapadia and a sensual Sridevi mastered the chiffon saree look, draping it below the navel and rendering it the definition of being a sultry and sexy garment forever.

Today, as the youth adapt themselves increasingly to Western wear, the saree does face the risk of extinction in urban settings. However, the stitched saree concept, first introduced to the world by American designer Zandra Rhodes and now mastered by every tailor master, will ensure that the saree marches safely into the next century. Printed, embroidered, dyed or worn coarse, the elegance of a saree is unmatched. So is its comfort. A beauty about India is sometimes when a woman is gifted a saree, even though she finds it fabulous or to her liking, a thought of sustainability and tradition sets in. Many pass on the garment from generation to generation. Sometimes

a bride wears a saree worn by her mother or even grandmother and in that moment many memories or emotional connects are established. The saree is one of the most treasured part of the trousseau. I believe this is India's gift to the world of fashion, elegance and class.

Jalebi

Delectable in Every Avatar

You will never see a leopard change his spots or a sunflower that grows in shade or a jalebi that is conical. Crispy, juicy and delicious, jalebis are a mass of circles intertwined with each other. Made from a white flour paste, rendered fluffy with baking soda that is poured in hot oil, the chef creates the circular shapes with swift hand movements akin to an artist at work on a canvas. No wonder many call it fluid art. Also no wonder that a twisted or sly person is often called a jalebi.

Translucent and seasoned with kesar, coconut shavings or grated pistachio, the jalebi coated with sugar syrup takes many shapes and is called by many names, but remains tasty in every avatar.

This sweet is much loved across the Indian subcontinent and is savoured in many ways. Epicureans of North India eat jalebis as an evening snack with masala chai and hot samosas.

People of Bihar start the day with kachori and jalebis. Dilliwallahs residing in Chandni Chowk love dipping a soft and thick jaleba in hot kesar milk and enjoying it at bedtime. Gujaratis cannot get enough of the sweet and salty jalebi-fafda combination. And jalebis closest and more shapely cousin *imarti* is often eaten cold in South India. Mind you, no North Indian wedding is complete if jalebis are not served with rabdi.

The beauty of the jalebi and *jalebiwallah* comes from the fact that no two jalebis are identical. And even though

they may look similar, jalebis across India taste different as somehow they adapt to the region, the time, the kadhai and the mood of the jalebi maker. Small or big, soft or crisp, orange or translucent yellow, a jalebi, never perfect in shape, is always perfect for the palette.

38

Games People Play

Popular Board Games of India

India has always been a sport-loving country with a strong competitive spirit dinned into us. And board games are as popular as cricket and football because they too have the capacity to bring the entire family together. The most popular board games in the country include carrom board, snakes and ladders, ludo, chess, and checkers. How can we forget that it was a board game that was the game-changer in the epic Mahabharata. It was the defeat in a game of dice that made the Pandavas lose their wife to the Kauravas. It is said that this game was popular among the Mughal rulers, especially Emperor Akbar, and the invading kings took the game to other parts of the world. The game has different variants including *pachisi*, which was later adapted by the British as ludo.

Indians have always taken their games a bit too seriously. This quirk is aptly depicted in Satyajit Ray's movie *Shatranj*

ke Khiladi in which two nawabs of Oudh are so engrossed in playing *shatranj* or chess that they effectively neglect their wives and fail to fight the takeover of their kingdom by the East India Company. Chess as we know it today evolved from the Indian game *chaturanga* in vogue before the 600 AD. Of course, modern-day chess is much easier and more fun.

Not only do these games give us an adrenaline rush, they also teach us important life lessons. For example, ludo helps us understand that although luck favours us, planning and strategy has an important role to play as well. Cutting across socio-economic barriers, ludo is also that one game that is thoroughly enjoyed by both an illiterate villager and an educated Indian city dweller. Snakes and ladders originated in ancient India as

mokshapat and was later taken to the UK in the 1890s. It is not exactly known when or who invented it, though it is believed the game was played as early as the second century BC in India. According to some historians, the game was invented by a saint named Gyandev in the thirteenth century as a moral instruction to children where the ladders depicted virtue and the snakes signified evil.

It is also important to note that ancient India neither glorified violence in its games nor celebrated quitting. Notwithstanding the technological advancements, these board games are anything but outdated. Typical of the Indian mindset, these games are low in their cost and also a strong example of *jugaad*. We Indians, with a mindset to never waste, never discard a game if the dice is lost. We find innovative substitutes like badams and buttons to replace them. Boards when torn are stitched back. These games unite families even though members compete with such gusto. Indian board games like ludo and snakes and ladders are a reflection of the Indian mindset to succeed against all odds, to overcome obstacles and fight competition. We grab opportunities like the ladder that pushes us many notches ahead in an instant. We give importance to role of luck, 6 on the dice helping us start a game, and see the snakes as symbols of how despite setbacks we have to re-emerge on our path to progress. It is incredible how these simple games inculcate so many life lessons in our young minds. We do not play with money but a striker that we call *gitti*! I feel money is not even the bait for us. It is a sense of competition that eggs us on to win just like we Indians master the art of progression in real life despite adversities.

Holi

A Sweet Affair to Remember

Indian mythology is dotted with tales of the good winning over the evil just like the story of the triumph of Prahlad over his father King Hiranyakashipu who wanted his son, a Vishnu bhakt, to worship him instead. When Prahlad refused to do so, the enraged father instructed Holika, his sister, to take Prahlad in her lap and sit on a burning pyre. Holika readily agreed to the plan as she had magical powers. She was confident that she would come out unscathed. Except Prahlad prayed fervently to Lord Vishnu and the opposite happened: he came out unscathed and his aunt was burnt to death. And, this feat of Holika *dahan* (the death of Holika) marks the arrival of Holi celebrating the triumph of good over evil just like Diwali.

The chant of *Holi hai* (It's Holi) and the request *Bura na mano Holi hai* (Don't mind, it is Holi) spread joy and laughter on the day. The gesture of smearing *gulal* (a bright-coloured

powder that is used at Holi) and other colours on someone's face symbolizes the removal of all differences among people of different castes and creeds.

Popular folklore has it that as a child, Lord Krishna would often cry to his mother, Yashoda, asking her, *"Radha kyon gori main*

kyo kala (Why is Radha so fair while I am dark in complexion?)?" Wanting to make her son happy, Yashoda advised him to smear a similar colour on Radha's and his face so that they both were equally "fair" and thus was born the famous Braj ki Holi that attracts millions of people to Mathura and Vrindavan on Holi. Even today Vrindavan, Krishna's place of birth, and Mathura, where he grew up, come alive on Holi. Denizens, smeared with every shade of gulal, sing away in praise of their Gopala. They treat themselves to scrumptious gujiyas, salty mathris and other savouries all of which are later washed down with bhang. Only God knows how gujiya, a stuffed pastry filled with pistachios and honey, got linked to the festival. But whatever the reason, it sure made Holi a sweet affair.

There are many kinds of Holi played in this sleepy town. Celebrations commence a week before in Barsana with a slightly violent version called the Lathmar Holi. On this day, women are seen roaming the streets of Barsana with sticks in their hands, ready to beat up any hapless man who dares to cross their path that fateful day! It is said to be a recreation of a famous Hindu legend according to which Lord Krishna (who hailed from the Nandgaon village) visited his beloved Radha's town, Barsana. If legend is to be believed, Lord Krishna, in Don Quixote style, would tease Radha and her friends, who in turn took offence at his advances and drove him out of Barsana by beating him with sticks. Keeping in sync with the legend, the men from Nandgaon visit the town of Barsana every year, only to be greeted with sticks (aka *lathis*) by the women there. Hence, every year, men of Braj run for cover as the feisty women of the city emerge on the streets, with thick bamboo sticks in their hands—with which they beat men playfully.

Holi symbolizes fun and frolic bringing out the child in everyone. The sight of large crowds pasting each other with

colour that is made from dry flowers, throwing buckets of water at each other or dancing in a trance is so grand that it has exerted a huge influence in Bollywood films. There are innumerable scenes in cinema that depict Holi. *"Rang barse"*, one of the most iconic songs, never goes out of fashion on Holi. Then there is *"Jai Jai Shiv Shankar"* that invokes the spirit of Lord Shiva and we are so deeply entrenched in our devotion that we ensure no *kaanta* (thorn) or *kankar* (stone) should deter the celebration.

Though there is little that is "holy" in Holi, we Indians can never get enough of it and it makes me immensely happy to see how we are ensuring that our heritage remains eternally preserved while striding into the twenty-first century.

Linguistic Diversity of India

Breaking Barriers of Communication

India has one of the largest number of languages in the world and if one includes the dialects, the plot thickens even further. There are more than 398 languages out of which 387 are still alive and 11 are extinct. The Eighth Schedule of the Indian Constitution, however, recognizes twenty-two different languages with the local, spoken language changing every few miles.

The beauty and testimony of our inclusive spirit is the way in which we have embraced Hindi in Devanagari script as one of the official languages of the Indian Union. Spoken by a sizable population, this language personifies the slogan: unity in diversity. Then there is the English language that came to us

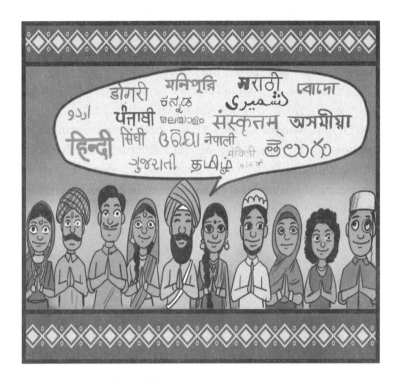

as a gift of our colonial masters. One that many Indians speak and write as remarkably as the British.

Unlike some of the European or Latin American countries where language becomes a barrier for tourists, communication does not suffer in India. Could be because we are hospitable people who are inclined to help rather than shrug off a guest's query in a foreign language. Instead we rely on a few loose words that bind many languages together, conversing like professionals with almost anyone. No wonder, we are not just a tourist haven, but also welcome businesses from across the world easily. Our spirit to adapt and mould ourselves like linguist professionals is the reason behind India turning into the global hub for call centres.

This beautiful country prospers beautifully in the acceptance of such diversity in traditions, cultures, languages, habits, customs, etc. Doing full justice to the popular song *"Sare jahan se achchha, Hindustan hamara"*, penned originally in Urdu as *"Tarana-e-Hindi"* by poet Allama Muhammad Iqbal.

Despite so many languages and dialects, Indian languages connect with each other at a subliminal level. Be it in Hindi, Punjabi, Tamil or Assamese we all share a spirit of communication, a subtext of emotion and a form of expression that remains deeply and truly Indian.

41

Our Love for Animals and Birds

The Desi Way

Indians have grown up on the staple diet of *Panchatantra* stories that were colourful, endearing and always had a happy ending. On the face of it, the Panchatantra appear to be children's stories involving animals and birds and offering moral lessons. However, Panchatantra was compiled to teach the principles of good governance to the three princes of King Amarasakti who ruled over a prosperous kingdom in ancient India. It is attributed to the scholar Vishnu Sharma who is believed to have written these short tales as early as 200 BC.

We Indians do not just love our animals, we revere them. Animals are worshipped in India in many ways: as deities like the elephant god, Ganesha and the monkey god, Hanuman;

as avatars like Lord Vishnu's fish, tortoise and boar forms and as *vahanas* like the swan, bull, mouse, lion and tiger. The vahanas are all vehicles (or mounts) of major deities and thus sacred by association.

We even have a temple that worships rats: The Karni Mata temple in Deshnoke, which is thirty kilometres away from Bikaner in Rajasthan. It houses thousands of rats that live in the temple and are held in high reverence. The ubiquitous mouse is also worshipped as Lord Ganesha's vahana. We worship snakes and even have a festival for them—Nag Panchami.

In Bengali culture, fish is given as a gift to the bride by the groom's family in order to wish her happiness and a long and happy marriage. We strongly believe that God can be

found in any form which in a way proves that Indians believe in coexisting peacefully. Of course, sometimes we also get sidetracked in our reverence by calling a wily person a *kutta* (dog) or an untrustworthy friend a *saanp* (snake) or a liar a *bichhu* (scorpion) but that is exactly the beauty of our quirkiness. It might seem difficult for the world outside to understand this duality of expression. How can the same snake, dog or scorpion be worshipped as well as linked to lowly acts. We equate the cow to a mother, make milk integral to our diet, yet, she can be often seen feeding off food from the streets. We equate the monkey to our beloved God Hanuman and feed them just about anything, turning them into a menace around temple towns. Examples like these exemplify our diverse emotions and feelings.

Our Betis

Our Devis, Our Pride

Stree Shakti is embedded in the Indian way of life. In our culture, goddesses are as powerful as gods, and brides are welcomed with a unique ceremony of *mukh dikhai*, which involves the unveiling of the bridal veil by her mother-in-law who showers her with lovely gifts thereafter. This gesture not just welcomes the bride into a new family but also expresses a deep sense of pride in this new member's presence and persona. All pivotal points of the nation where magnetic fields exist have shrines dedicated to the goddesses—Vaishno Devi, Kasar Devi, Chamunda Devi, Kamakhya Devi. We love our Durga Ma, Saraswati Ma, Kaali Ma, Sherawali Ma, Jagdamba Devi and all the other manifestations of the Devi. We see her as the mother and protector of all.

As a society, we are a bundle of contradictions. We worship the female energy, yet there are reports of the girl child not

getting her right to be born and to be educated. It is a hard fact that a daughter is often not welcome into families because they prefer a son. Discrimination against women is rampant in Indian society. The pressure of dowry, the fear of sending her away to a new home after her marriage and the constant fear of her safety keep lowering her chips.

Our ambivalent attitude towards the girl child is a result of a lack of education and misinformation triggered by rampant poverty and ignorance. Added to which is the draconian

tradition of giving dowry at the time of the wedding of a daughter that necessitates the bride's father to gift nearly half his wealth to the groom's family. A poor man with hardly any education and savings finds himself helplessly bound in this vicious evil. A lack of jobs in our society for women and the constant fear for their safety add to this apprehension. As a result, Indian households often express a desire to not have a daughter, denying themselves the biggest pleasure God can gift a family. Don't they say, a son is yours till he gets married, but a daughter is yours forever. Things though are changing and the winds are slowly blowing in favour of the girl child, thanks to the intervention of the government and various NGOs, spread of education, and awareness reaching the grassroots. As a result, the girl child is now slowly getting her rightful position back.

This change is reflected in the child sex ratio which in the population census of 2011was 919 females per 1,000 males aged 0 to 6 years. According to the National Family Health Survey 2020–21 (NFHS-5), India's sex ratio stands at a 1,020 females per 1,000 males in 2019–2021.This wind of change started blowing over India when in 2015, Prime Minister Narendra Modi launched the *Beti Bachao, Beti Padhao* (Save the girl child, educate her) scheme to help end discrimination against daughters in India. The banning of sex tests further tipped the scale in her favour and female foeticide statistics dipped. The government went on to extend free education to our betis, opening opportunities for them in sports and the task force. It is a matter of immense pride that we have iconic women like P.T. Usha, P.V. Sindhu, Sania Mirza keeping the flag flying for women in India.

43

Parathas

Be Indian, Eat a Paratha

It is difficult not to get into a food-induced coma after eating a hot, stuffed paratha with dollops of white butter and a bowl of curd. A hearty breakfast most Indians absolutely love to indulge in on a laid-back Sunday morning. Made from wheat flour that is kneaded by hand and then rolled into a perfect round shape with a rolling pin, a paratha can be plain or stuffed with a variety of vegetables like radish, cauliflower, carrot, peas and mashed potatoes. Finely chopped green chillies, onions and fresh coriander mixed with the filling add the extra zing.

You could say that the paratha is the Indian pancake. They are a decadent indulgence for the rich who cook their parathas in ghee and devour them with dollops of white butter. They are also a staple for the farmer who eats his parathas with a raw onion and down it with a tall glass of buttermilk. A paratha is the one dish that binds us together. It is devoured in many

forms and flavours across the country, carrying with it endless hyperlocal possibilities. Almost every region of the country has its own version of the dish. The Mughlai paratha in Kolkata is stuffed with keema. The Sindhis make dal jo phulko where a lentil spice mix is stuffed inside a flour blanket, almost like a savoury version of the Maharashtrian puran poli, which is

essentially a protein-filled, sweetened stuffed paratha, also relished in Gujarat. There are restaurants dedicated to the humble paratha in India. There is even a street in Chandni Chowk called Paranthe Wali Gali. Kneading it well is also an art, and chefs, especially those belonging to legendary roadside dhabas, can dish out sixteen-layered lachha parathas, pudina parathas and even garlic parathas! The eating methods of parathas are just about as diverse as the methods of making them—they can be eaten with tiny onions preserved in salted vinegar, sweet mango chutney, jaggery, white butter or sweet lassi flavoured with cardamom. Parathas can be cooked with some inspiration as a gourmet meal.

Parathas are our constant companions. We pack aloo parathas for a train trip and devour them with a spicy mango pickle. They become our instant midnight meal, filling our tummies and satiating our tastebuds. We spice up any boring meal with an ajwain or onion paratha. Nothing beats the taste of a lachha paratha with a bowl of butter chicken or a flaky soft Malabar paratha with Chettinad chicken.

Our parathas (be that stuffed or frozen) have travelled to almost every corner of the world, as a much-loved wholesome meal. This has enabled the food processing industry to grow in leaps and bounds. Be Indian, eat a paratha.

Chakki

An Equivalent to the Modern Gym

Grinding wheat at home—before commercial grinding mills were opened near our homes—was not considered a menial job. It was common for our grandmothers to slowly grind the wheat whilst striking a deep, conversation with another lady sitting across her and helping her in the act. It was an occasion for women to socialize. *Chakki* or grinding stone was a common sight in traditional Indian households. It played a dominant role in not only grinding wheat, but also grinding maize and pearl millet to retain their freshness.

Prisoners in the Raj era used to grind wheat into fine flour for the villages and cities around them to consume. No wonder, grinding flour on the chakki has now become synonymous with serving a jail term. Who can forget superstar Dharmendra, alluding to this in his iconic dialogue from *Sholay*, "When I dead, police coming ... police coming, *budhiya* going jail ... in

jail *budhiya chakki peesing*, and *peesing* and *peesing* and *peesing* (If I die, the police will come and take the old lady to jail. In jail she will grind flour all day, every day)."

Working the chakki is often recommended to pregnant women to ease childbirth. *Chakki Chalan Asana* (Grinding Flour Asana) is also a part of yoga which improves spine health and reduces backache. It also helps reduce belly fat and is a good alternative to going to the gym. So, it is time to bring the chakki back to its rightful place in our homes. Or maybe place it next to that treadmill you paid lakhs for!

45

Universal Motherhood

The Power of the Feminine

Everyone adores their mother, an undying reverence for her inherent in anyone born, whether as a beast or as a man. Indians however possess and love many mothers, real and notional. Of course, the mother to whom we are born to is the first mother we know and love most. Though she competes closely in affection with *dadima* (paternal grandmother), *badima* (eldest aunt), *pishima* (father's sister), *nanima* (maternal grandmother) and *mashima* (mother's sister), etc. These mothers in flesh and blood bestow on us so much love, nurture us and bring us up to be good citizens.

Then there are not-so-real mothers whom we love as much that is, Bharat Mata. We love, adulate and protect her with our lives. When the Army captures an important post or when we win a match against a foreign opponent, we chant *Bharat Mata ki jai*. Our national song *Vande Mataram* is a standing testimony

to this love. We also love the *gau mata* whose contribution to our lives is manifold. The milk industry thrives because of her. The cow dung is the fuel that runs rural India.

The Mother Goddess is India's supreme divinity. Myriad are her shrines and unending her boons. We pray to Durga Ma to make the impossible possible. The Sherawali Ma, sitting atop

a fierce tiger, is the queen of our hearts. Ma Parvati teaches us how to love. Thus, motherhood is highly revered in Indian culture and is often associated with divinity and spirituality.

We have thousands of songs on our ma from gods to mothers to motherland. The word "ma" in India is power, a dose of energy and a sense that all will be well when we have *"ma ka ashirwaad"*.

In an iconic scene from the blockbuster film *Deewaar*, onscreen brothers Amitabh Bachchan and Shashi Kapoor are seen having a deep conversation about the different paths their lives took. One is an honest police officer and the other is a smuggler. The smuggler (Bachchan) boasts that he has earned himself a great life. He lives in a mansion, drives an expensive car, has an enviable bank balance and trunks full of cash. He then disdainfully asks his younger brother (Kapoor), a low-profile salaried person about his gains in life. Kapoor comes up with a short and crisp answer, *"Mere paas maa hai* (I have my mother)."* That one, simple answer tips the fortune in his favour because a mother by your side is worth more than a fortune at your feet.

We Indians have gracefully accepted Nirupa Roy as the on-screen mother as she played the role of a typical mother in hundreds of films. The movie *Mother India* is a strong portrayal of our value systems. Manoj Kumar, another acting legend, made endless movies on India as "ma" and each one was a runaway hit. We love melodrama and often make this melodramatic statement when we want to challenge someone, *"Agar tuney apni ma ka doodh piya hai to aaja maidan mein* (If you have drunk your mother's milk, fight back)".* Somehow, we have added "ma" to every ma-ment, sorry mom-ent, sorry I meant moment!

Vellapanti

The Art of Doing Nothing

In most countries of the world, "just chilling" is welcomed as a break. In India, it is seen as an excuse to make the unemployed youth in the house run mindless errands. In the scheme of a hierarchical Indian family and society, those who do nothing are called *vellas* (idle people) and those who do not do anything for a while are called maha vellas (very idle people).

They are ordered to errands in their vella time like taking the dog for a walk or fetching *dadaji* his paan. Sometimes when these poor kids are caught watching TV along with other family members, out comes a voice that they are doing *vellapanti* and are ordered to lay the table for the next meal or open the door.

Mind you, the status of a vella is upgraded the moment he/she gets a job or falls in love and acquires a girlfriend or boyfriend with the aim to get married. Then the family suddenly holds them in high esteem and elevates them to a

part-time vella status.

This kind of a torture extends to the office as well. If an employee, especially in the lower rungs of a hierarchical office, is caught chatting by his boss, he is told, *"Velle kyun baithe ho, kuch kaam kar lo* (Why are you sitting idle? Do some work)*"* without specifying the work that needs to be done.

Vellas take a u-turn when they share a *razai* with another vella during winter to conserve energy and fight the cold. Interestingly, the moments of being vella gets instantly transformed into high action if an activity of interest pops up and the excuse for rest is abandoned for a break from boredom.

I am surprised that there are no tea and coffee lounges in India called Vella Lounges, but I will not be surprised if a group called Associations of Vellas or Vella Friendship Clubs pops up.

47

Kabadiwallah

Heart of India's Robust Recycling Industry

In many parts of the world, waste management is a systematic process. One drops off one's scrap neatly packed inside black bags at depots authorized by municipal departments who collect and recycle them. A World Bank study reveals that India is the world's highest waste-generating nation and the annual waste generated is likely to touch 387.8 million tonnes in 2030. To put that in perspective, the landfill needed to accommodate it will have to be as big as the sprawling city of Bengaluru. Hence, recycling as a habit should be encouraged.

Thankfully, Indians have always believed in recycling, much before recycling and upcycling became such a major global trend. Selling newspapers, old bottles and metal parts to *kabadiwallahs* was the norm. Indians were born "environment conscious". The way of recycling things traditionally should be celebrated and nurtured. We try and extract the maximum

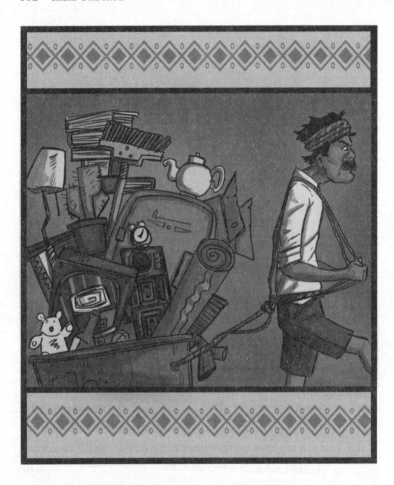

value from our trash because we truly believe that nothing we possess must go to waste.

Hence, we save the trash we can make money out of, piling it up till it is worth at least a few hundred rupees in value. Once the pile is in place, we patiently wait for the kabaddiwallah who announces his arrival in an all-too-familiar shrill voice shouting, "Kabadiwallah, Kabadiwallah!" The moment we

meet him, a smile spreads across our face and we happily begin the necessary process of bargaining to arrive at a per kilo rate for our *raddi* (discarded stuff) and then have him weigh the pile of newspapers and periodicals on his rickety scale.

Raddi has various grades. While newspapers are sold instantly, textbooks do not get discarded immediately because these are handed down to various relatives who are delighted to receive these along with the notebooks with ready homework!

Mind you, the argumentative, sly fox kabadiwallah buys it all. While scrap metal is sold by the kilo, white goods like TV, washing machine, air conditioner, mixer grinder go for a song. Or shall we say at scrap value? When he hands us the cash in exchange of our trash, our joy knows no bounds. A clever businessman, he also pays a critical role in supporting the mammoth industry of spurious whisky and perfumes. His eyes light up if you hand him a bottle with its label intact. The irony being that you pay thousands for a bottle of Scotch whisky and at the same time inadvertently and unknowingly support the thriving counterfeit market. So, mind you, every time you sell a bottle in fine fettle you are simply making whisky risky!

48

The Desi Art of Bargaining

How to Avoid Thagna in Deal-making

Indians are very value conscious and that reflects in their deal-making capabilities. Ever conscious about the value of our transactions, we like to strategize each deal to ensure that we do not end up losing instead of gaining or as they say in Hindi *lene ke dene na pad jaaye* (to sustain a blow while trying to hit). And since we do not like to be short-changed in a deal, it makes the entire ecosystem of deal-making more conscious of cheats and cheating.

Nevertheless, *thagna* is a practised art with a famous ladoo maker in Kanpur, Thaguu Ke Laddoo, proudly proclaiming, "*Aisa koi saga nahi, jisko humne thaga nahi. Agar thagne se hai bachna toh dur ka rishta rakhna* (There is not a single loved one

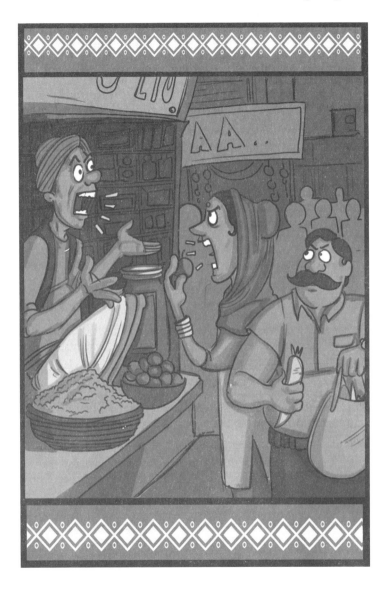

we have not swindled. If you don't want to be fooled, maintain distance)". In simple words, we like to create a capitalist setup that enables people to transact at their free will. Bargaining

is at the genesis of almost everything in India, from a ride in a rickshaw to buying fruits and vegetables to closing salary negotiations with the HR. And the motto of *"Ek haath dena ek haath lena* (Take from one hand and give from the other)" is religiously followed to ensure the deal is fair. This system of relying on someone's verbal promise enables the creation of several financial instruments unique to our society from *hundis* to verbal promises *(zubaan dena)* to proud proclamations that *pran jaye par vachan na jaye* (one can give up one's life but not break one's promise).

Sometimes when an intention is doubted, the sanctity is conferred by using assurances like *"ma kasam* (Mother swear)" to inject a mother's assurance into the ecosystem. Many a time *"teri kasam* (I swear on you)" works too and completes the transaction as being sacrosanct and honourable. We are such suckers for melodrama that we bring it into simple financial dealings. When we sense distrust in someone, we express our good intentions by saying *"Hum apke bhai nahi hai, kya* (Am I not your brother?)?" or *"Bharosa nahi hai, kya* (Don't you trust me)?" Of course they do not trust us, but if we drill it into them by such filmi dialogues, we are able to close the deal in our favour quickly.

49

For the Love of Daru

Lower the Bar

Indians love their *daru*. However, we have made drinking spirits a hurdle race for the youth who have to officially wait till the age of twenty-five before they can drink alcohol in public. This age limit being a wee bit questionable given that there is so much of "adulting" happening otherwise before that age, like getting married at the age of eighteen for girls and twenty-one for men. They can marry, but cannot officially raise a toast to their holy union. What absurdity!

People can vote, fight for the country, but cannot drink at the age they are legally considered adult in this country. Also, chances are that by the time the couple legally drink, they are already parents. A man is mature enough to buy rubber to plan his family but he cannot buy a pint of beer. There is no reason to explain why the same person who can marry and bring new life into the world at a particular age

cannot decide whether and how much alcohol they want to consume at that age.

They can vote for the next Prime Minister and the party in power but they cannot celebrate the win at a bar. This law surely needs to be changed but knowing the long-winding process which precedes the reframing of any legislation, this could take ages.

50

Kanaster

A Repository of Dreams

India has a unique system to facilitate change. For example, if we buy something from a shop that is not transacting in the electronic mode, the shopkeeper gives us toffees or candies as change. Unfortunately, the shopkeeper never accepts toffee when change is unavailable with the customer.

In some houses, there is an understanding between the employer and his domestic help where the help can break a certain number of glasses beyond which there is an automatic deduction of the salary to compensate for the crockery broken. But there is no system to give him a bonus if he does not break a single glass.

In many parts of India, people, especially housewives, hide their savings in secret boxes or in drums of rice with the hope that the rice, which symbolizes prosperity and piousness, will make their savings grow. These boxes are called *kanaster*s and

the money in them when accumulated over time helps the mother buy that new shirt or bike for her kid with a caveat that the kid cannot divulge the source of the money to anyone, especially their father. Thus, the kanaster lays the safe foundation of many dreams.

Indian Music

The Divine Connection

It is a known fact that India has the oldest and possibly the most evolved tradition of rhythm. Not just mere mortals, our gods too love music and this is depicted in numerous temple frescoes and sculptures across the country. They are mostly seen with a mridangam, one of the oldest Indian percussion instruments. Many Indians believe it to be a divine instrument or *deva vaadyam*. Many paintings and sculptures of Lord Ganesha show him playing it. Legend has it that Nandi, Lord Shiva's *vahana,* played the mridangam to perfection, matching the God's *tandava nrityam*, step for step. The mridangam is played today as an accompaniment in Carnatic music.

Indians immerse their souls in the "sound of music", be it a folk song, a Bollywood number or a tarana. Now, being the nation of jugaad we do not wait for well-designed musical instruments to create a rhythmic sound. We can convert a

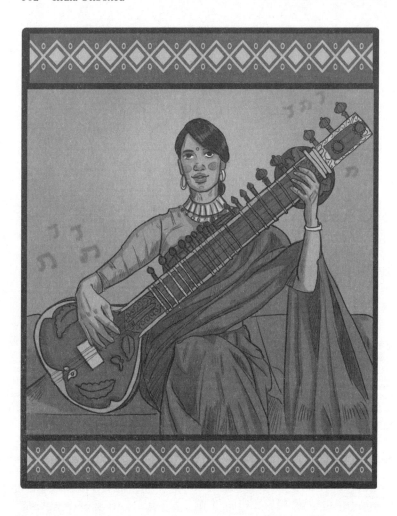

Dalda tin or a table into a tabla and even someone's head into a source of sound resulting in a minor concussion sometimes!

Indian innovation comes to the fore in the common man's *dafli* (a frame drum with bells circling it), a unique instrument for folk artists in the country. In Bollywood, it is often shown as a mode to vent frustration and silence the world around.

Veena, now nearly extinct, is considered to be one of the world's oldest string instrument. Bharata Muni's *Natya Shastra*, believed to be the oldest surviving ancient Hindu text on classical music and performing arts, mentions the veena. Old sculptures in stone and bronze show our gods and goddesses immersed in its sound. Goddess Saraswati is always shown playing the veena. Raja Ravi Varma depicts her playing a southern-style Saraswati veena, while in pahari paintings she can be seen playing a rudra veena. What is important to note here is that we always depicted our gods enjoying the finer facets of life.

Pandals

Here Today, Gone Tomorrow

In India even the mundane is elevated to a state of art. A predictable craft turned into a masterpiece. No, I am not talking of the kimkhwab silk woven by our gifted weavers in Benaras. I am referring to the pandal, the ubiquitous large tent made of fabric. It is like a palace made from fabric, here today, gone tomorrow.

A pandal can literally come up overnight. One of my most vivid childhood memories is the sight of a preliminary pandal structure being built of bamboo tied with ropes. Since pandals are mostly associated with festivities or weddings, the sight of labourers entering our colony with a bunch of bamboos, always excited us.

The Indian tent, unlike its practical, Western counterpart, is like a peacock with a plume. Its outer surface, made from sturdy canvas cloth, can be sometimes plain and sometimes a

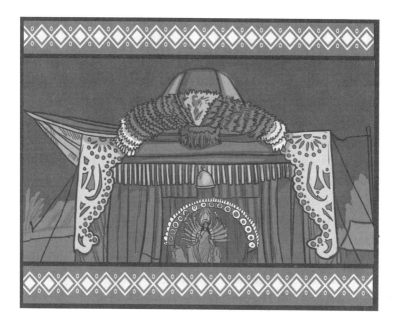

riot of colours with various motifs and patterns that are applied on the sturdy fabric.

The pandals serve many purposes. They can be crafted for a wedding, a community puja or even a little one's *mundan*. They are also set up for the sombre prayer meeting for the departed. In which case, the pandal takes a pristine white avatar.

The art of pandal making reaches its pinnacle during Durga Puja, especially in Bengal. The many beautifully decorated puja pandals are one of the main attractions for the spectators. During the festival, lakhs of well-dressed people are seen hopping from one pandal to another in Kolkata. Each pandal is built around a theme ranging from current affairs and popular Bollywood films to folk art forms and temples. In fact, you can think of pandals as giant art installations. In 2022, the festival

was awarded the UNESCO tag of Intangible Cultural Heritage of Humanity.

The beauty of the pandals lies in the imagination and skills of those who build them. Working around themes as varied as world monuments and current news, these pandals are like canvases where the artists express themselves. When the Durga Puja season starts, the entire world rushes to Bengal, especially Kolkata, to feast their eyes on these must-see pandals. Social media pages, newspapers and television fill up with images of people praying before a resplendent Ma Durga, selfie shots inside and around the majestic façade of pandals, and people dancing. What is ignored are the hundreds of hands that worked many days and nights to bring this space alive and to ensure that this tent, sky high and sprawling, is not just beautiful but also safe. I take this opportunity to salute these unsung heroes.

53

Mumbai Local

A Soap Opera on the Move

Introduced in 1867, Mumbai's local trains are possibly the world's most historic suburban railway system that still remains the lifeline of the city. Operating 2,342 train services on routes spread across this bustling metropolis these trains carry more than 7.5 million commuters daily. Making them the most tightly squeezed of all public transports where hundreds of humans get stuffed into a compartment like sardines in a tin. Yet, no matter how crowded, uncomfortable and filthy, these trains carry thousands of hard-working Mumbaikars to their workplace and back. It is impossible to imagine Mumbai without this super-efficient and affordable transport system.

Every morning, an average middle-class Mumbaiker follows a schedule with clockwork precision in order to catch a train. A sea of humanity, including office-goers, students,

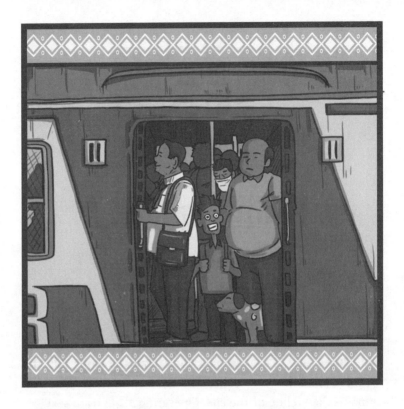

labourers, times themselves to the last minute. They can beat many in precision when it comes to boarding the same train every day. They set their clock, arriving exactly at 8:04 a.m. at the bus stop to catch the bus at 8:05 a.m., which will drop them to the nearest station at 8:12 a.m., just in time for them to run across the platform to board the 8:15 Churchgate local! The train is already chock-a-block with chattering humans. Yet they have mastered the art of getting a toe in, assured that their co-passengers will push the rest of their body inside the train.

Once inside, passengers are seen huddling together with strangers. Despite that, loud conversations fill every inch of the

moving locomotive. The women's compartment is filled with conversations relating to their household chores and family, the constant juggling they have to do to balance personal and professional life, the trouble they face dealing with stubborn children, etc. These heart-to-heart talk with co-passengers can be very therapeutic. The women, always on the move, use this travel time efficiently. You will often encounter women preparing for dinner by peeling peas and cutting vegetables. After all, who else but a Mumbaikar knows the utility of time and purpose? Given the distance they travel each day from their far-flung home to their workplace.

On the other hand, the men's coach is quieter, as men generally do not like to discuss their problematic lives. Yet, some sights and sounds are a given: like the man with a mouthful of gutka huddled in the corner of a bogie, struggling to speak with the person on the other side of his phone, or the view of many newspapers being read by men who only get the time to read them once they are seated in their train, or the sound of shuffling cards played by fellow passengers who board the same train each day in the hope of playing a game of rummy together. Their briefcases turning into a card table!

The crammed compartment often turns into a stage with a folk artist singing a Bollywood number, or a magician showing his tricks, or a dancer dancing away. No, these are not state-sponsored entertainers. They are beggars trying to make a living in an innovative way. Then there are food vendors who entertain the passengers by singing while selling their wares. You will also encounter *bhajan mandalis*, groups of people with dhols, and harmoniums singing bhajans to pass time.

These short and tumultuous journeys bring people from different walks of life together who share a common goal: To reach their destination on time, and hopefully alive! The real

beauty of the Mumbai local is its affordability and consistency. You can find it plying even in the most torrential of rains. A citizen of Mumbai can be rest assured to reach his destination even if squeezed at all ends—the only saving grace being that there are separate compartments for women and men. It is like a live stage showcasing a lot of drama and entertainment depicting an India that moves together despite its differences.

Essence of Indian Hospitality

Atithi Devo Bhava

As a child, I used to wonder what the fuss was about when we welcomed a guest in our home. I remember my mother would prepare a lavish spread, lay out her finest porcelain that I was never allowed to touch and my father would give his undivided attention to making drinks at the bar for the guests. All this to ensure that our visitor had the most amazing time at our home.

I never quite understood why we went out of our way to make them feel so welcome and pampered, until one day when I walked into a newly launched hotel in my hometown and was greeted with the same warmth and hospitality that my family and many Indian families extend to guests.

Atithi devo Bhava is at the core of Indian hospitality. It means the guest is equivalent to a God. And this principle is deeply engrained in the Indian ethos.

I truly believe that Indians love the adventure of meeting people more than the commerce of hospitality. For us, tourism is not a business, but a culture to be carried forward. The success of the Indian hospitality industry can be attributed to the people of this country who are a powerhouse of talent. Hospitality is a noble virtue and one of the most practical and interesting persuasions of our social life.

Lota

A Tribute to Indian Design

Nothing can be more multipurpose than the Indian lota. It is used in more ways than you can ever imagine. When made in glistening copper, it turns into a vessel for worship, carrying the sacred *charnamrit* (nectar gathered from the feet of the Lord), which is yet another unique Indian tradition. Charnamrit is sweetened water infused with mint leaves, When crafted from cast iron, it is used as a cooking utensil. In plastic, it accompanies the farmer each day as he bathes and goes about his working ablutions at the local pond. When made in carved and decorous silver, it becomes your most revered objet d'art. Mind you, it even holds the ashes of the deceased. No wonder, you can witness the following graffiti all over the holy city of Haridwar:

"Iss se pehle ke koi aap ko laye lota ya jar mein,
Kuch din toh bitayein zinda Haridwar mein!"

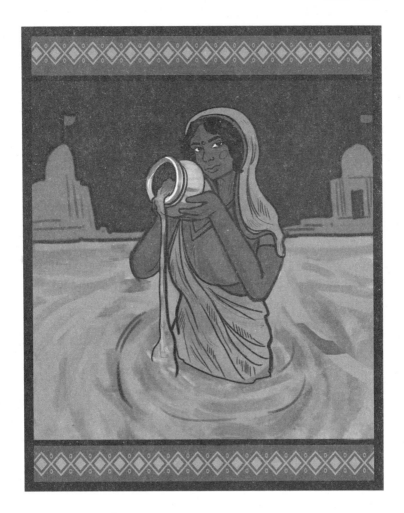

(Before someone gets your ashes to Haridwar in a jar or lota, spend a few days alive in the city.)

The lota is a small, round-shaped vessel made of brass, copper or steel and used mostly to carry water. It is used during prayer

rituals, weddings and other sacred ceremonies. In Ayurveda, it is considered healthy to drink water from a copper vessel. And in yoga, it is used for *neti kriya* which is a type of yogic nasal cleansing exercise. In many Indian homes, one would often find an attractive array of lotas: a large one for storing water; a smaller one for bathing or a miniature lota for the home shrine, which stores sacred water from the River Ganga.

The lota is so unique in shape that I feel we need to pay a tribute to its creator who came up with this interesting shape of a water carrier—round at the bottom and open-mouthed enough to allow the stored water to be poured out easily.

An indecisive person is called a *bin pende ka lota* (a lota without a base). It is also colloquially used to refer to a person who may switch their loyalties. This is because a spherical lota without a base tends to roll over in unpredictable directions when kept on an uneven ground.

Kite Flying

A High Like None Other

Gliding through the gentle winds in the distant skies, kites personify freedom and fun. Colourful, flamboyant and cleverly crafted, kites are not just a great example of Indian craftsmanship, but also symbolize celebration. Made from the finest translucent, handmade paper that is carefully glued on to a gentle frame of bamboo needles, the Indian kite is a sheer marvel.

Nothing is more Indian than the kites. On Independence Day every year, the skies of Indian cities, especially Old Delhi, turn into a riot of colour as many enthusiastic denizens fly their bright kites. It is almost as if the people of the walled city are reliving the joy of feeling free on that fateful day of 15 August 1947, with the shrill cries of "Wah Ustad (So good, boss)" and "*Boi Katte* (A war cry when you cut your opponent's kite loose)" filling the air. The frenzied bid to take your kite

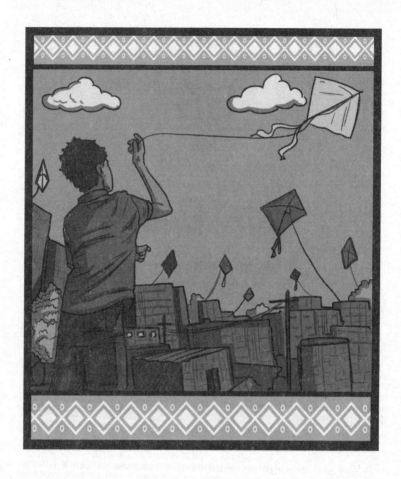

higher and higher is what gives the participants an adrenaline rush. Meanwhile, warm pakodas, piping-hot jalebis, chai get devoured by the enthusiastic kite flyers.

Similarly, on every Makar Sankranti there is enthusiastic kite flying in Jaipur. The pop patterns on the kite match the vibrant *safa*s (turban) worn by the kite runners. In this case, snacks include ghewar, kachodi and other *pakwans*.

However, kite flying in Gujarat takes on an Olympic level during Uttarayan, also known as the International Kite Festival. It takes place on Makar Sankranti every year, and is celebrated all over the state. The main event is hosted in the capital city of Ahmedabad, which is also called the kite capital of Gujarat. The day is declared a public holiday. Everyone takes to the rooftops to fly kites and compete with their neighbours. Undhiyu (a mixed vegetable including yam and beans), chikki (sesame seed brittle) and jalebi are a few food items relished on this day.

Months before, the production and selling of kites begin on the streets of Ahmedabad, especially in Patang Bazaar, a special market dedicated to selling kites in all shapes and colours. For the week preceding the festival, it is open twenty-four hours a day for all kite lovers.

Although kites are not an Indian invention, the way we design them, the joy with which we fly them and the happiness they give to everyone involved are what make kite flying such a desi thing.

57

Indian Moustaches

A Historical Love Affair

They come in many different shapes and sizes and are called by equally inane names: cookie duster, crumb catcher, tea strainer, face lace, lip shadow, manometer. Add to that the vision of a *muchchha* drowning his hairy mooch in lassi and you have the story of the moustache totally covered.

The Indian man's love affair with the moustache is historic, especially for men from North India. But, hey, mind you, a *muchchhad* did not appear out of thin air. In fact, there is a long, laborious, well-groomed, airbrushed tale to the hair.

It all began with the long battles and days spent on the battlefield that gave birth to the long moustaches worn by Kshatriya warriors on their well-chiselled face. A moustache slowly became a caste symbol for a Ranjore ka Rajput who was recognized by three definitive traits, each more ridiculous

than the other: kidnap a girl (blistering barnacles), ride a horse (hmm) and grow a moustache (we all saw that coming)!

However, this hairy tale predates the era of the warring Rajputs. One such reference is to the small male steatite sculpture that was found in Mohenjo-Daro of the poster boy of the Harappan kingdom, better known as the priest man who is seen to sport a moustache with a neatly groomed beard. By the 1860s, moustaches were made compulsory for all the British armed forces. The King's Regulations said: "The hair of the head will be kept short. The chin and the under lip will be shaved, but not the upper lip …"

Well, the twirly tale of the muchchhad continues: Be that of the Maharaja, the much-loved mascot of the Indian carrier Air India for decades. He was seen wearing his long *mooch* with pride. Or the nomad of Rajasthan who proudly immortalizes

the phrase *"Moochhe tan ke rakho* (Keep your moustache bushy and twirled at the end)". Or even the Indian policeman who is always seen sporting what you call the Dallas moustache or the Veerappan variety of moustache making even the monstrous seem magical!

I am most intrigued by the psychological impact they have had on an Indian man's sense of masculinity. In a patriarchal society a young lad is told by his father, *"Moochon ko taan ke rakhna* (Keep your moustache upright)", almost as if his self-pride depended on them! Then there are parallels drawn to historic (often make-believe) characters who were known for their moustache! *"Muchein ho toh Nathu Singh Jaise* (If you have to, have a moustache like Nathu Singh's iconic moustache)". We all have grown up seeing our grandmothers sport an unkempt upper lip that was nothing short of a moustache. One that could give our grandfathers' carefully cultivated moustache a stiff competition!

58

Chowkidar

Guarding the Nation

The Indian watchman or gatekeeper or chowkidar who sits outside your building is the equivalent to the Ramu Kaka who lives inside your house. Whilst Ramu Kaka looks after all your needs in the home, Chowkidar bhaiya protects you from the outside.

The word chowkidar is a derivative of the Urdu word *chauki* which refers to one of the four outposts on the periphery of a typical village that guard it from intruders. However, with the villages merging into a city, chowkidar today is simply the man who sits at our gate guarding our home. Apart from protecting our homes, which he cannot do with just a *danda* (stick), he is also our man Friday. He fetches our food order, ensures our kids (and dogs) do not run out of the door, guides our car when we are reversing, shares the neighbourhood gossip.

Indeed, like the local paanwallah he knows every family's
dirty secret. When a young man got home last night, with whom

and in what state! Who has recently bought a luxury car and what new appliance arrived at whose doorstep including when! Best part is that he will happily dispense all this information to us, *maska laga ke* (buttering up the tale).

His look is well defined: He sports a danda in his hand which does not even scare a dog away along with a torch that often does not work; a *kambal* (blanket); possibly a *gamchcha* around his shoulders and a childlike innocent expression. We are able to sleep peacefully knowing chowkidar bhaiya is out there, guarding our homes!

59

Benaras

The Soul of India

"Benaras is older than history, older than tradition, older even than legend and looks twice as old as all of them put together."—Mark Twain

Benaras to me is the ultimate realisation of a man's connect with Mother Earth. From the peace derived by merely sitting on the banks of the Ganga in Assi Ghat, to the sight of bodies being carried in their last journey to Manikarnika Ghat, to the vista of birds in flight as if they are leading the departed soul to heaven. Each of these experiences symbolizes a message that the journey called life is transient.

Benaras or Varanasi, the home of Kashi Vishwanath temple, is considered to be the bridge between heaven and earth, a crossing point where gods visit this world and mortals travel to the next. It is the place Lord Shiva brought his wife,

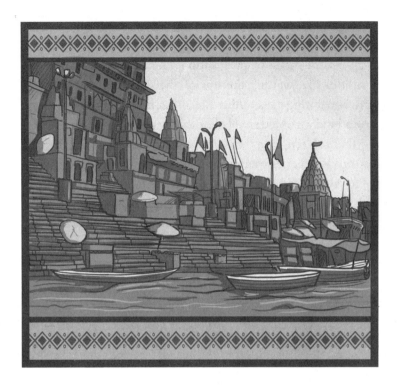

Parvati. The town derives its name from two rivers—the Varuna and Assi.

The Assi Ghat exudes a mystical aura that few can replicate. Flanking the fast-flowing Ganga, this riverbank boasts of a skyline filled with palaces, ashrams, temples and shrines of Vedic education. Palaces that were built by the royal families of India and Nepal for their old family members to breathe their last in, temples that flanked these palaces, there is even a haveli named in memory of Munshi Premchand. The Manikarnika Ghat, *which* is one of the oldest ghats in Varanasi, is famous for both pilgrimage and cremation.

Somehow the ghats of Benaras always make me wonder about the many ways we revere the river. The Ganga *jal* is seen as an instant mode of purification. Hence, it is used on many occasions like wetting the lips of the departed, sprinkling at birth and during havan. Above all, it is a beautiful binding factor around India's unfettered belief that water is the elixir of life.

Our reverence for this sacred river is so strong that when we lose our loved ones we immerse their ashes in the Ganga, when we have achieved something, we choose to bathe in the Ganga and when we commit any sin we take a dip into the river to absolve ourselves of them. Mother Ganga is the lifeline of India.

Kerala Boat Race

The Pride of God's Own Country

Vallam kali or the snake boat race is a traditional boat race held in Kerala, which includes competition of various paddled longboats and *chundan vallam* or snake boats which can be up to 100 feet long. It is a form of canoe racing, and uses paddled war canoes. There are many snake boat races held in the state mostly from July to September. Aranmula Boat Race is an ancient and one of the most revered boat races of Kerala. It is well known for its grandeur and unique history. The Nehru Trophy Boat Race, held on the second Saturday of August every year, is the most popular of all of them. Its winner is awarded the Nehru Trophy. Held on the Punnamada Lake in Alappuzha, the competition has gained huge fame, and attracts many tourists.

In an effort to promote this sport and showcase Kerala's backwaters to the world, the Government of Kerala initiated the

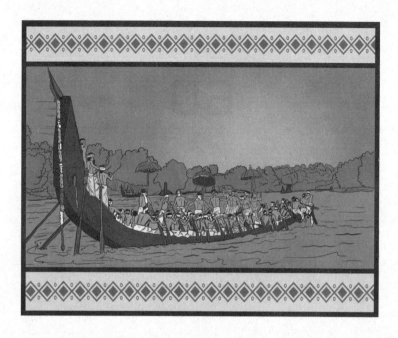

Champions Boat League in 2019. In doing so, the government was simply echoing the sheer gravitas of this sport that has such a deep influence on the popular culture of Kerala. A state known for its bountiful rivers and backwaters, Kerala and its people feel a soul connect to the many houseboats that ply its waterbodies.

When diving into the history of Kerala, one would find cultural evidence of this sport during an early thirteenth century. King Devanarayana of Chembakassery commissioned the construction of a war boat named Chundan Vallam for a war between the feudal kingdoms. A famous carpenter of the day was bestowed with the responsibility of creating the structure of the boat. Thus, the technical methods for creating these snake boats are around eight centuries old. Of

the snake boats still in use today, the Parthasarathi Chundan is the oldest model.

While tourists, both domestic and international, simply spend a few idyllic days living in house boats that fill the backwaters of Allepey or Allapuzha, the people of Kerala treat these wooden abodes like their home and hearth.

Indian Railways

An Outstanding Example of Colour Coding

Nothing binds Mother India like the Indian Railways. The myriad tracks that spread across its length and breadth almost feeling like arteries that link the entire nation to her ever-giving heart. There is possibly not a single Indian who has never boarded a train. Some of us who grew up in the 1970s still nurse warm memories of going to our grandmother's home in a train with our entire family. Carrying with us a three-tiered lunch box full of *puri-aloo-achar*, a *surahi* (earthern pitcher) filled with cool and fresh water and a holdall, inside which our mothers rolled freshly washed sheets, pillows and blankets!

The railway is considered to be one of the most preferred modes of transportation in the country not just due to its affordability but also because of its connectivity, its easy access and the at-home feeling that it exudes.

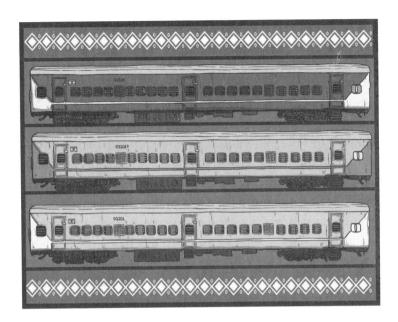

While there are many aspects that make the Railways unique, there is one which makes it stand out and that is the wide variety of train coaches. Each one marked in a colour that defines its make, destination and origin.

Now, the Railways caters to a huge population, hence the rail network is divided into multiple zones, types and sections. To make each of these identifiable from miles away the Railways have opted for the universally decipherable method of colour coding.

Notably, a vast majority of trains in India like mail, express and passenger trains have blue-coloured coaches. The Rajdhani Express trains are red in colour. Shatabdi comes in light blue and grey on top and bottom. Tejas Express trains, which are among the fastest trains in the country, are painted yellow and orange. The Double Decker Express train coaches

have a combination of yellow and red. They are unique, and no other train uses this colour combination.

The Duronto series of trains have the characteristic vinyl wrapping of yellow-green livery instead of paint. Gatimaan Express, India's first semi-high-speed train, comes with blue-coloured coaches with a yellow stripe and a grey bottom. In addition to different colours, even the colour of the stripes on the sides of the coaches indicate something extremely significant. For example, the diagonal yellow or white stripes at the end of a coach means that it is an unreserved coach.

More recently the supersonic Vande Bharat and Rapid X trains have given a sense of speed to this mode of transport. Accelerating from 0 to 100 km per hour in less than fifty-two seconds these trains are medium-distance trains that serve cities that are less than ten hours travel time apart.

In a nation where many cannot even read which train they are rushing into, the colours almost work like Morse code. So, when a young lad from a remote village goes to pick his uncle from a train, all he is told is that *"Chachaji* will emerge from a blue train!"* And that seems enough for him to get it right! Or when a Ramu Kaka is going to work in Delhi for the first time from Haldwani, he is asked to get into the Delhi-bound red train, and lo and behold, he reaches Delhi. *Vive Le* lateral thought. *Vive* India!

Desi Parenting

A Twisted Saga

I would like to state at the very outset that I do not promote or support verbal abuse, nor am I canvassing for people who use abusive language. What I want to share is the unique, slightly bizarre way in which Indian parents profess their love for their children by using profanities and unparliamentary language. They do not hesitate to express their affection for their children with a strong "I love you!" but often like to call them by names that sound even more colourful in Hindi. At times, they like to establish a notional tie of kinship between their children and animals by uttering abuses like *ullu ka pattha* (an owl's son), *gadhe ka bachcha* (donkey's kid), *khotte da peo* (father of a donkey), and so on. However, sometimes, these expletives are laced with so much love that they almost sound like compliments!

Indeed, Indian parents' way of showing love for their kids is often reckless and harsh. Without any fear of repercussions

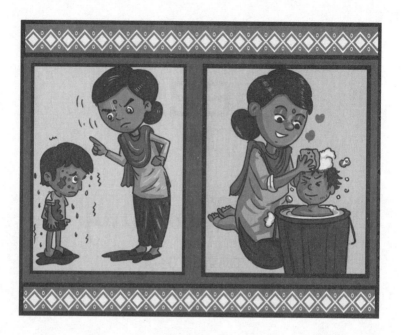

and state control, they even spank their kids, or at least pretend to be doing so. They ignore their cries for a toy and run around them with a stick in hand when they make mischief! Desi parents surely do know how to channelize their anger. They have the presence of mind, even when seething and simmering with rage, to instantly convert an ordinary object, like a *belan* or a broom or chappals into a weapon. And they do all this with absolutely no fear of losing their kids to foster care or being called cruel and callous.

However, in reality, desi parents' love for their children is unconditional and their stern demeanour just an act. Actually they do not praise their kids easily because of the superstition that *Maa baap ki nazar jaldi lagti hai!* In other words, there is a commonly held belief that even parents can cast an evil eye on their children.

Shagun ka Lifafa

Enclosing Love and Good Wishes

These are integral to every traditional Indian ceremony and celebration: colourful, flamboyant envelopes (*shagun ka lifafe*) carefully enclosing crisp note(s) within their folds are handed over to loved ones to mark a special moment in their life. These envelopes are much more—they are a token of love, good wishes and affection.

These envelopes literally envelop every momentous moment of our lives, lighting up the celebrations with their bright technicolour appearance. Now the shagun ka lifafa is present everywhere: be it on the arrival of a newborn, his first birthday, his *mundan* ceremony, his graduation, wedding or housewarming with his new bride. Shagun is also given by elders to their loved ones at important festivals such as Eid, Diwali, Dussehra, Rakhi, Teej.

Have you ever wondered why shagun is given in odd numbers? Why are amounts like Rs 101, Rs 501 or Rs 1,001 gifted and not Rs 100, Rs 500 or Rs 1000? The number 1 signifies the beginning.

Another interesting belief associated with the additional one rupee is that the real debt lies on the receiver who will have to meet the giver. The one rupee is the symbol of continuity. It strengthens their bond. It simply means, "We will meet again". Often a one-rupee coin is attached to the envelope lest someone forgets to put it in the envelope.

Although the shagun envelopes have undergone various transformations in terms of style and design, their intent remains the same—giving a shagun is considered auspicious.

Now, as weddings turn complicated and celebrations become staged events, the shagun ka lifafa has become a statement piece with embossing in gold, lining in velvet, etc. However, one thing remains intact: the presence of the one-rupee coin on the face of the envelope, warding off the evil eye and holding the promise of many more happy rendezvous.

64

Mauli

The Sacred Thread of Protection

Fashionistas worldwide love wearing stylish bracelets. We Indians, on the other hand, wear auspicious threads in very many shades of faded red, yellow and orange. And sometimes even black in a bid to ward off the evil eye.

Mauli or *kalava* tied around the wrist (left wrist for women and right wrist for men) is a common sight in India. Some wear it for years till the skin beneath it turns a shade lighter and you forget when and why you wore it in the first place. It is like a badge for a spiritual Indian. The mauli, seemingly thin in nature, is of great value for Hindus.

Although they come in various colours, it is the red mauli that is considered the most auspicious as it symbolizes the colour of fire and blood, and hence, associated with energy, strength, power and determination. The sacred thread is usually offered to the deity during puja and, later on, tied on the wrist

of the worshipper with the belief that it will protect them from any mishap and negative energy. Hence many believers call it *raksha dhaga*.

Mind you, the tradition of tying a mauli around your wrist goes beyond religious beliefs. It is tied for scientific benefits as well. According to Ayurveda, almost all the essential nerves pass through our wrists. When we tie a thread around the wrist, it provides some balance to our *doshas* (energy principals that govern our tendencies, affinities, structure, functions and even susceptibility to certain types of ailments) and enhances the circulation of blood. Just like the many other traditional Indian rituals such as fasting, surya namaskar, the practice of tying a mauli around your wrist is firmly based in science.

Nimbu Pani and Lassi

Perfect Companions for the Summer

Imagine it is scorching hot and you hit upon the *Aladdin ka chirag*. What would you ask from the Djinn that pops up magically from it? Something *thanda, thanda*, cool, cool? Maybe a tall glass of chilled water infused with lemon juice, spiced with black salt and sprinkled with sugar. Voila! You have asked for the Indian alternative to the fruit punch loved by the British or the sherbet that keeps the Arab throats moist. The Indian nimbu pani, an instant energizer, is that one drink that never lets you down.

Nimbu pani or shikanji could easily be called India's Mojito sans the frills. Nimbu pani is not only refreshing and a fool-proof digestive, but also nutritious as it is packed with Vitamin C, which helps in cleansing the liver and keeps the skin hydrated.

A perfect summer thirst quencher, you can sip a nimbu pani anytime, anywhere and with anything. Except it has a different

effect at different times of the day. When taken lukewarm in the morning with a dash of organic honey, it works as a body cleanser. During the day when consumed as a chilled drink it is an instant refresher and when sipped hot, almost like a desi toddy in the evening, it works as an instant energizer.

Now, nimbu pani also has a pal called lassi, the tall glass of buttermilk, a favourite among the people of Punjab. Although, of late it has gained tremendous popularity across the entire Indian subcontinent. The sight of a woman, dressed in salwar kameez, churning away curd with a hand-held *mathani* (wooden churner) in a large pot is a common sight in rural Punjab. Originating in Punjab, lassi is deeply linked with the folklore of that rich state.

The recipe is simple: blend the yogurt, add adequate water to make a drink, sprinkle sugar or salt as per taste, add crushed ice and serve it in a tumbler. Cumin and cardamom can also

be added to this manna from heaven. A great digestive, a glass of lassi boosts immunity, improves bone health and is good for the skin.

The thought of a lassi takes me down memory lane to the experience of drinking rich creamy and delicious lassi at a roadside dhaba. Served in a tall steel or brass tumbler with a thick layer of *malai* (fresh cream) swimming on top and paired with parathas that are topped with dollops of white butter or chhole bhature served with spicy pickled mango. Lassi, like any other drink has its many variations: There is the flavoured lassi, such as rose lassi made with fresh yogurt, sugar and Rooh Afza (rose syrup), fruit lassi that has yogurt blended with mango or banana, dry-fruits lassi and chocolate lassi.

66

Hawai Chappals

The Multi-purpose Footwear

It is not divine yet it is held with deep reverence by every Indian possessing a pair. It is one of the best levellers, cutting across caste, creed and economic strata and is present in almost every Indian home.

Hawai chappals have been in use forever, dating back to our grandmothers, great grandmothers or maybe even before that. Have you ever wondered why these shoes are named hawai chappals? Some say that the history of the hawai chappal has a connection with the Hawaiian Islands. The special rubber used for the chappals is found from a local tree on this island. The poor man's hawai chappal is not blessed with great looks or presence but are highly comfortable, durable, making it a household favourite.

Now, mind it, you cannot take the hawai chappal lightly as it is also a weapon in disguise, especially for women. Flying slippers can hit hard.

Another reason why this not-so-fancy footwear gained popularity among Indians is for its ability to punish children. Desi parents often use the chappal as a tool to punish their children when they disobey them. *Mummy chappal se marengi* is the scariest threat for any Indian kid.

The average Indian's attachment to this footwear is so deep that we continue to wearing them even when we have fancy fit flops and loafers to choose from.

Chhappan Bhog

An Offering of Gratitude and Joy

Chhappan bhog (a feast made of fifty-six dishes) is a prasad that is typically offered to Lord Krishna on Govardhan Puja or Janmashtami. Like many other feasts from our mythologies, this too has an interesting story behind it. The farmers of Vrindavan used to offer rich foods to Lord Indra, the god of storm and rain so that he would remain happy and bless them with timely rainfall and a good harvest. Little Krishna found this practice unfair, so he told them to stop offering the meal. This made Lord Indra angry and he sent torrential rain to the small village of Vrindavan. The rain continued for days and resulted in a flood.

To save people from drowning, Lord Krishna called everyone to Govardhan Parvat (mountain) and lifted it on his little finger so that everyone could take refuge under it. He stood still holding the mountain for seven days until Lord Indra

realized his mistake and stopped the rain. During these seven days, Lord Krishna did not have a single grain of food. It is said that he usually had eight meals every day. Therefore, at the end of the seventh day, the people of Vrindavan cooked fifty-six dishes and offered them to him as an expression of gratitude.

The Chhappan Bhog typically comprises dishes that were said to be Lord Krishna's favourites including a variety of cereals, dry fruits, vegetable dishes, savouries, chutneys and pickles. Lord Krishna was particularly fond of *makhan* (white butter) and sweets. There is also a larger philosophy at work that dates back to ancient Ayurvedic beliefs.

When preparing the Chhappan Bhog for Lord Krishna, it is believed the people cooking become even more sacred as they

offer a part of themselves to the gods. Chhappan Bhog is a way of connecting with a higher power and offering up gratitude and joy in the form of delicious, simple food, just the way that Lord Krishna would have wanted. Because Indians take their food very seriously, as a farming nation, we lay great emphasis on our three-square meals a day.

Jugaad

A Tribute to the Great Indian Spirit

Webster's Dictionary defines it as "a flexible approach to problem-solving that uses limited resources in an innovative way". Business schools define it as smart management decisions that are innovative yet simple, high on yield yet frugal and totally out of the box. Yes, you guessed right, I am talking about "jugaad" here. The Indian variety of frugal engineering that is legendary and indigenous to this colourful land full of masterminds.

The Hindi word *jugaad* translates as "quick fix" or "hack" and expresses a quintessentially Indian concept. It describes a mentality or approach that seeks solutions in adversity, describing how the world is negotiated by improvisation and ingenuity.

Stories of Indian jugaad are aplenty: Big families in Haryana use a washing machine to churn curd into lassi. Indian farmers use glucose bottles to build a drip irrigation system. Migrant workers live inside construction pipes in overcrowded cities.

A family in Madurai has turned their broken water tank into a parking spot for their scooter. A farmer in Jharkhand has replaced the engine for a tractor he could ill afford with the engine of a second-hand scooter.

Jugaad is simply finding a solution in the most ingenious manner. To me, it stands for the great Indian spirit that never wanes and the wonderful Indian survival instinct that sees us through it all.

British Chicken Tikka Masala

Our Contribution to Britain's Culinary Tradition

India and the United Kingdom have a shared history and a deep relationship that is both good and bad. The two nations have imbibed and adapted many things from each other's living cultures, eating habits topping this list. Be it the way we replaced the Indian tradition of drinking milk with sipping tea or replacing millets with wheat and white flour. This kind of exchange continued even after India attained Independence.

The British learnt to love our Darjeeling tea, our chintz prints, our spices and our silk. But more than all this they loved eating a nice, spicy chicken. Hence, it is not surprising to see that chicken tikka masala, born in the North West

Frontier Province and now found on the menu of many British restaurants, is fast becoming UK's national dish.

This is the incredible story of how one of the million indigenous Indian recipes turned into a British favourite. It has surpassed even fish and chips or Yorkshire puddings. The British have, however, given their own twist to this dish by making the masala milder, the consistency moist and the gravy very tomato rich. Central London even has a street called Curry Mile famous for its concentration of South Asian restaurants

serving curry. There are plenty of YouTube videos offering the recipe urging housewives to rustle it up at home. The UK supermarkets always have it stocked, and Indians, Pakistanis and Bangladeshi chefs clamor to call it their own.

Unlike its original avatar, the British chicken tikka masala is not barbecued or dry. It comprises pan-fried chunks of boneless chicken marinated in spicy yogurt and dunked in a thick, creamy tomato-rich gravy. Many attribute the origin of this dish to Mrs Balbir Singh's iconic recipe book that she penned in 1961. She was the one to put Indian food on the British map. Her curries are cooked by all and they say, chefs in London combined her curry and tikka recipe to conjure up the chicken tikka masala.

Milder in its masala quotient, and far creamier in its consistency than the tikkas we eat at home, the British chicken tikka masala is reflective of the inclusive character of our culture. Even if they were our colonizers and India their prized colony, we choose to forgive and forget, share and flourish.

Soaked Almonds

Simple, Desi Solution for Superintelligence

Deep in our hearts we are constantly seeking magic potions to enhance our intelligence and strength. We hope that, like Popeye, we too could attain superhuman powers by simply devouring spinach. Interestingly, Indians firmly believe that we can attain super intelligence by eating almonds. All it requires is soaking almonds overnight and chomping on them the next day. Five is the ideal number.

There is science behind soaking almonds: it makes them more digestible and reduces anti-nutrients like tannin. Many health journals claim that eating soaked almonds helps in weight loss, brings glow to your skin and boosts brain function. Little wonder, Indian parents can be seen lovingly feeding their children almonds regularly. They believe that their consumption influences grades.

Almonds are also known to keep cancer away, help absorb good nutrients and keep the memory sharp. Hence, the superfood is also fed to ailing and ageing senior citizens. With the belief that dementia, cancer or arthritis will never touch them.

If almonds sharpen memory, how do we forget to eat them or soak them overnight? Also, if they make Einstein out of our kids, why do some have report cards full of red marks? All these doubts, however, are for the sceptics only. No non-believer can dampen (pun intended) our trust in the age-old practice.

Reuse and Recycle

An Indian Fetish

Indians are a frugal lot. We love hanging on to all things defunct and broken in order to save our heritage or simply cling on to a cherished memory. No, we do not like to discard anything—neither material nor notional. Our oral storytelling tradition is the strongest example of how we never forget a fable or a folk tale. Our feuds get passed on from one generation to the next.

When this relay race transcends to material life, the story takes an unbelievable turn. Trousers, once worn by daddy dear, are resized for his son, or, his younger brother. After which, they are either given to the driver's son or used as a duster.

Saris often meet a similar fate, going as hand-me-downs from mother to daughter till they are unwearable. So, what does the lady do? She hires a good *rafoogar* to mend the holes and strengthen the sari with a thin sheath of muslin to wear it as a dupatta. That is, if she is not trading it for shiny new steel

*bartan*s (utensils) from a travelling salesman who gives her new steel utensils in exchange of old garments. Now, if the sari is lined with silver zari you take it to the silversmith, burn it for silver and use the money to buy that pair of silver anklets you were eyeing for so long.

Younger siblings are often at the receiving end of this fetish. They end up going to school buried in their elder sibling's blazer that fits like a robe. Not to miss the trousers that are held together by a very strong belt at the waist with the hemline rolled up nearly six inches. After all, they have to wear the trousers for many more years.

Textbooks meet the same fate with the whole colony eyeing the discarded books of a topper. Toys, footballs, cricket bats, roller skates and even dolls with a leg gone, an eye lost, a dress torn get used many times over.

Similarly, reusing things till they splutter to death is another fetish. So, the toothpaste is snipped and cracked open from various ends till the last drop is used. Cars are discarded only

when they reach scrap value. Sofas are upholstered repeatedly till the springs in them cave in. Carpets, duvets and family linen are used till they reach their last thread literally. Little wonder then that we believe in rebirth. After all, the soul too must be recycled.

72

Traditional Indian Games

A Source of Priceless Joy

The global toy industry gets increasingly sophisticated each year. With new toys, tech-driven games, newer versions of Barbie dolls hitting toy stores and making the fetish to own newer toys endless among children. As a result, there is no handle on the expenses incurred by the poor parents.

In sharp contrast, an average Indian kid does not need a room full of expensive toys to experience joy. He can have a good time out of nothing. And for that, he has a variety of desi games to rely on. He can play *pithoo*, a game played with a stack of seven flat stones piled on top of each other. Or he can take out his make-believe car made out of discarded tin cans attached to a rope and race around, making a loud rattling

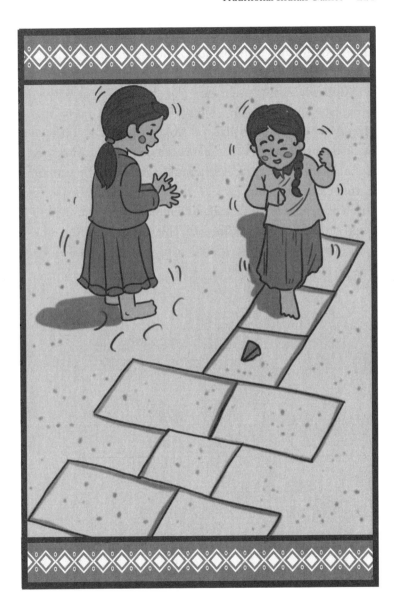

sound. Once bored of that he can rush to a nearby pond to bathe to his heart's content.

If rains push him indoors, he can play hide-and-seek or spin his top, competing with friends or siblings or sometimes even himself.

Meanwhile, his sister can play hopscotch or *stapoo* or participate in Antakshari or play Posham Pa a game that is played like London Bridge or Kokla Chappakki (Drop the Handkerchief) game. What makes these outdoor games special is that these are a great leveller and not bound by economic status, caste, religion, etc., of the players. And they do not cost a bomb. Be it Gilli Danda or Chhupan Chhupai (Hide and Seek) or Chor Sipahi (Police and Thieves) or Kho-Kho—these games contribute towards enhancing the social skills of the kids greatly.

73

Khajuraho Temples

A Progressive Depiction of a Way of Life

Indians treat the temple as a place to eat, pray, dream and hope. Sculptors since time immemorial have been chiselling away at stone walls depicting daily life from birth to death with a few intimate details left out to imagination.

However, the Khajuraho temples have no details of the private life left to the imagination. Almost every wall of the temples carries a sculpted figure of Lajja Gauri, the perfectly endowed apsara, making love in an explicit way. The temple walls seem to visually represent the *Kamasutra*. Indeed, this temple of sculptures in various love-making positions can beat any Italian fresco or sculpture in its sexual depiction.

Built by the Chandela kings between 950 and 1050 AD, they had many invaders squirm, calling them too candid in their sexual representation. Even the British made a big noise around these temples, calling them decadent. Many of our nation's

founders echoed their disdain as well. A group of overzealous social reformers once planned to raze or deface the temple carvings. Mahatma Gandhi supported such action. However, Rabindranath Tagore stood up for Khajuraho and urged his contemporaries to preserve the temples as national treasures.

Indians have never shied away from sharing the tales of the "birds and bees". Our ancient Sanskrit text *Kamasutra* remains a bible on the subject. Despite our puritanical facade, we are the most populated country of the world. Now, if we were so strong on abstinence, could so many babies bloom? The temple carvings in Khajuraho have a different story to tell!

India was way ahead of the world in terms of realizing the limitations of being a closed society, and educating people on the intimate *bandhan*. A UNESCO World Heritage site, Khajuraho temples aptly represent the mindset of the Indian who accepts every aspect of life without malice or prejudice. They are a proof that our art is inclusive and real, besides being exquisite.

74

Kota

Where Dreams Become Reality

Guess what Sundar Pichai, senior vice-president, Google; N.R. Narayan Murthy, co-founder, Infosys; Chetan Bhagat, bestselling author ex-IIT, IIM; Raghuram Rajan, former RBI chief; Vinod Khosla, co-founder, Sun Microsystems; Deepinder Goyal, founder Zomato; and Nandan Nilekani, credited for building Aadhar and a successful entrepreneur, have in common? Well, they are all products of the Indian Mecca of engineering studies, the IIT (Indian Institute of Technology). I am sure all of them must have had a guru or a coach who helped them prepare for the joint entrance examination (JEE) that got them a one-way ticket to success.

Now what if all these gurus, coaches and colleges were in a single city? A sleepy, old town famous for Kota doria fabric (a combination of cotton and silk woven in a square check pattern) and the mava milk cake now runs a Rs 6000-crore-plus business

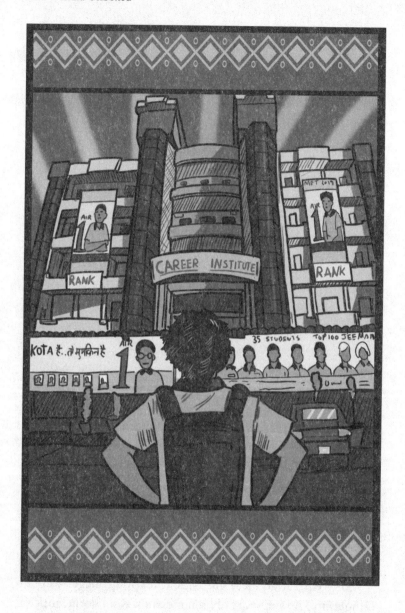

of creating and hiring geniuses. The whole city is dotted with
schools and coaching institutes with well-oiled machinery to

create an assembly line of geniuses. Kota in Rajasthan is fast emerging as a Mecca for coaching institutes that prepare school students for the tough IIT-JEE and NEET exams. A small, near rustic town where all of India's nerds come together with the focused vision of getting into one of the few engineering and medical colleges of India. More than 1,50,000 students enrol in a cluster of coaching institutes that grill them over a slow fire, preparing them for the ordeal of sitting for an entrance exam.

The Kota coaching industry is not only helping JEE and NEET aspirants to get into the IITs, they are also hiring back students after they have completed their education as teachers—that too at annual salaries that range between 50 lakh to 2 crore!

Indians and their mastery over science is well known. And the tradition of giving scientists, mathematicians and CEOs to the world is continuing. Kota's talent factories make it possible by creating an assembly line of IITians!

75

Special-purpose Temples

Because Efforts Need That Extra Push

Such is our belief in God that we went ahead and made special-purpose temples simply because we are a society with an optimistic mindset, and desire to get results not only by efforts but also by blessings of the Almighty!

Our thirty-three crore-devis and devtas are a very giving lot—they grant our every wish. Well, almost—right from blessing us to be a "mother of a thousand sons" (not one or two) to ensuring that we pass our exams, to helping us find our prince in shining armour.

Now every devotee has a special favour to ask for. To start with, a majority of Indians desire to settle or work abroad. For that, we have Chilkur Balaji temple, popularly known as

Visa Balaji Temple in Hyderabad, famous for helping people get their visas, especially the US visas. And once the devotee's

desire is granted, gratitude is offered to the Lord by performing 108 parikramas of the inner shrine.

From Hyderabad we travel to Bikaner to find ourselves in Karni Mata's temple that is filled with rats. Interestingly, feeding them can fulfil our deepest wishes. But what if your wish is specific? Then there is the Golu Devta temple in Uttarakhand that helps the devotee win a litigation. All the devotee has to do is make petitions at the temple, using stamp papers, to seek the desired decree in litigations. On accomplishment of the wish, the deity, believed to be an incarnation of Lord Shiva, is shown gratitude by hanging bells to a tree in the compound.

Not far away from there is a temple on the edge of Bhimtal. Praying to the deity here can rid you of all kinds of itches. Drive two hours from there and you reach the Maha Mritunjay Mandir where you can pray for your long life.

Indeed God is that power we all rely on and these enchanting temples are the means to reach them. Whenever I hear of these unique monuments of hope, I am reminded of the saying, *Umeed pe duniya kayam hai.*

The world spins on hope.

Acknowledgements

Writing a book is harder than I thought and more rewarding than I could have ever imagined. I will start by thanking Anshu Khanna for helping me put together this book. From the ideation phase to the completion, she was always there for me. A special thanks to Shekhar Sharma for executing the splendid illustrations.

Thank you Ajay Mago, the dynamic publisher of Om Books International, for seeing merit in the book. I am grateful to Chief Editor Shantanu Ray Chaudhuri for his expert guidance and Jyotsna Mehta for her immense patience and skill in editing the book. This book would not exist without the support from the team at Om Books International.

But most of all, I would like to thank my fellow Indians—I learn from you every day! We are a magnificent country of great diversity and uniqueness.

Ramu Kaka in them. The genteel actor A.K. Hangal played this role in so many Bollywood films—the saviour, the caring butler who may not be a family member by blood but definitely is by heart. He made the hero such yummy food that if the French were to judge it, the Michelin home-cooked food star would easily be his. Often in the middle of the movie when a devilish villain discredited his honesty and questioned his loyalty to his saheb, he was seen sticking to his truth stoically often with folded hands! Ramu Kaka was even seen sacrificing his life when the *dakus* came to plunder the haveli, heroically saving his saheb and his family. He even took the blame for a wrong done by his beloved boss's son as a testament to his unwavering allegiance. Despite being the real hero in so many reel and real-life moments, he is taken for granted. Carrying this role forward from film to film, he has compacted reams of backstory into a smile or a glance. So, when we tease someone by calling them, *"Yeh hamare ghar ka Ramu Kaka hai"* we are actually complimenting him for his reliability.

Ramu Kaka's tiny staff quarter is invariably equipped with a modest wardrobe, a transistor, an old television and pictures of his real family plastered on the walls. The shelf displays his most important belongings, *kesh tel, chashma* and talcum powder. Alas, as we gravitate from joint families to nuclear households, and exile ourselves to self-sufficient islands of our own making, we have somewhere outgrown the need for our dearest Ramu Kaka. But he remains as an emotion; a stereotype of a fearless protector of our family. Often mediating for us with outsiders though he is not known to take any sides at home. For him, every family member is of equal importance. Ramu Kaka thus symbolizes the dedication and love that only a man Friday can be credited with.

Nazar Battu

An Eye for an Eye

"Teri pyari pyari surat ko kisi ki nazar na lage, chashme baddoor", sung by the maestro Mohammed Rafi, is an all-time classic. The Persian term "chashme baddoor", which literally means "far be the evil eye", is extensively used in many parts of the world as a silent prayer bestowed on our loved ones, in the hope that the evil eye keeps far away from them. We Indians too have kept our loved ones away from the evil eye of conniving, envious humans through the stoic and powerful time-tested magical powers of a *nazar battu*. A practice that prevails since time immemorial and has stood the test of time.

A perfect antidote to the envious gaze of a neighbour or an acquaintance, the nazar battu is empowered by our trust and belief that it will never let us down. It is our safety valve that protects us from all things bad, be it ill health, loss of wealth, betrayal or the wrath of Nature. Despite the great

leaps made by science in modern India, the nazar battu is held in high esteem as our faithful antidote to all things nasty and bad.

We give it the highest *darza* in our hearts and the highest point in our houses, so that it protects us from anyone outside casting an evil eye. Although, mind you, the nazar battu feels no moral responsibility to protect us from "insiders" as it believes in being equally fair to every member of the family. So *ghar ke jhagde* remain outside his jurisdiction as he must at all time balance his love for every member. *Ghar ke andar* everyone is equal in his rose-tinted vision.

There is a practice of keeping all sorts of nazar battus in Indian homes—from a ripped pair of shoes, a *kala tika*, a torn piece of black cloth to the mandatory *nimbu mirchi* at our main door. There is also a mask of a demon with its protruding tongue hung outside our homes to protect our territory from any stranger who walks through our door with an intention to put a spoke in our peaceful life. Its country cousin can be found in green fields in the form of a hand-painted mud urn with an imposing face placed atop a bamboo stick to ward off birds and save crops from any *buri* (bad) *nazar* (look).

We protect ourselves too from the evil eye in ways that are uniquely Indian. A baby is made to wear a silver *tabiz* around his neck while a rising star of the family is made to wear a *kala dhaga* or red thread on his wrist. A very visible black bindi on an otherwise unblemished face of an exquisite bride keeps her safe from the evil eye. Kohl, prepared over a flame rendered from pure ghee, also does the magic. We do all this to ensure we remain in good health and make progress in our lives without attracting the evil eye.

Since the evil eye brings suffering to people, many believe that the best way to counter it is to use a talisman that looks like an eye. Basically, it is an eye for an eye. In this unique practice, we Indians demonstrate that while we like to safeguard ourselves by warding off evil, the last thing we intend to be ourselves is evil.